\mathscr{A}
MARITIME
HISTORY
of the
STAMFORD
WATERFRONT

A MARITIME HISTORY
of the
STAMFORD WATERFRONT

*Cove Island, Shippan Point
and the Stamford Harbor Shoreline*

KAREN JEWELL

Charleston London

THE
History
PRESS

Published by The History Press
Charleston, SC 29403
www.historypress.net

First published 2010

Manufactured in the United States

ISBN 978.1.60949.075.1

Jewell, Karen.
A maritime history of the Stamford waterfront : Cove Island, Shippan Point and the
Stamford harbor shoreline / Karen Jewell.
p. cm.
Includes bibliographical references.
ISBN 978-1-60949-075-1
1. Stamford (Conn.)--History. 2. Waterfronts--Connecticut--Stamford--History. 3.
Yachting--Connecticut--Stamford--History. 4. Stamford Region (Conn.)--History, Local. 5.
Long Island Sound (N.Y. and Conn.)--History, Local. I. Title.
F104.S8J48 2010
387.09746'9--dc22
2010045528

Contents

Acknowledgements

During the process of writing *A Maritime History of the Stamford Waterfront*, I was very fortunate to have a handful of people who would answer my numerous phone calls and seemingly endless questions without even a hint of annoyance in their responses. All of these invaluable resources could have easily shrugged me off at any point in time, as they certainly had enough to do in their own business and personal lives. Instead, they graciously helped me in numerous ways in my quest to gather just the right information for the project. For that, I am extremely grateful.

In no particular order, I would like to express my sincere appreciation to the following nautical aficionados for the generous donation of their time, data, images and, above all, patience in helping me to complete the task at hand: Ron Marcus, for steering me in the right direction during the beginning stages of research; Skip Raymond, for not blocking my phone number on his caller list and for working with me on finding the pieces to a couple of important puzzles; Tom Anderson, for being kind enough to allow me access to a variety of archived photos and historical records; Christopher Meek, for supplying much-needed images; Nellie Guernsey, for making it possible to include a vital component of the local maritime heritage; and my mother and father, whose enduring support continues to fuel my own enthusiasm.

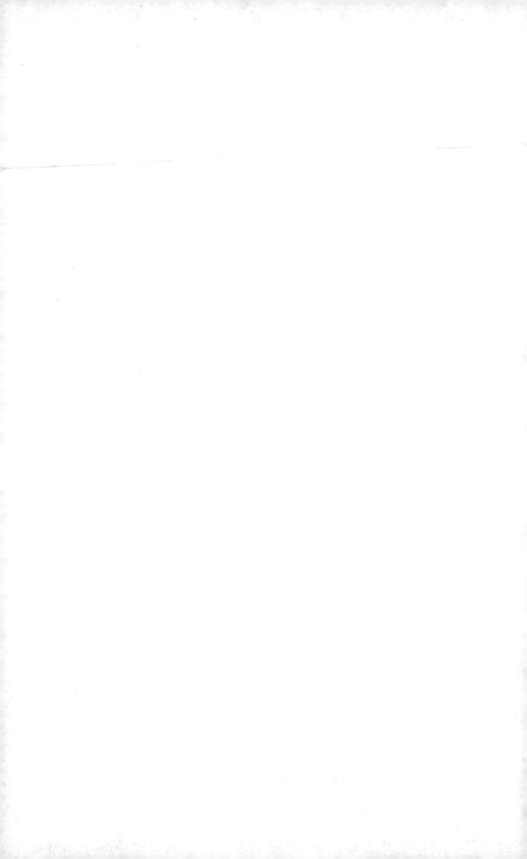

Introduction

When I initially set out to write this book, my thought was, "What an easy project this will be!" That overly confident sentiment was borne from the innate connection that I felt I had with the city's shoreline. For nearly twenty years previous, my experiences had included anything and everything nautical, from positions as dock master to charter broker to yacht broker to running a successful boat maintenance business. Presumably, or so I thought, there would certainly be more than enough information available for the job at hand.

Shortly after embarking on the research process, however, it became painfully apparent that the voyage from Point A to Point B was not going to be quite as straight of a line as originally hoped. Although there have been volumes upon volumes of excellent literary pieces published in the past by accomplished and recognized authors regarding the history of Stamford as a whole, there seems to be very little about the waterfront specifically. While lamenting about this realization one day with Stamford historian Ron Marcus, he was able to offer a rather insightful and enlightening observation that his wife had once shared.

She said, "It is because all of the books have been written by landlubbers!" By George, I think she's got it.

Once that important piece of information was understood and accepted, the entire endeavor began to take on a whole new shape. Clearly, there was

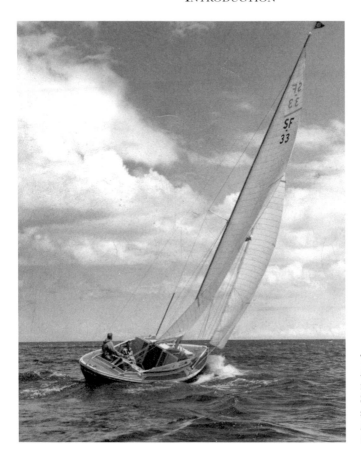

The sailboat *Palawan*, a regular on the Stamford sailing scene. *Courtesy of Hathaway, Reiser & Raymond.*

going to be a lot more work required on my part than first expected if this was, indeed, going to become a reality. And, obviously, making it a reality was the plan.

So forward it was, and as fate would have it, the journey ultimately turned out to be far more exciting than I could ever have imagined. What was already a fascinating subject to begin with became an even more intriguing topic the further I dug. With a little patience, history generously revealed itself in a grand way. Perhaps it had simply been waiting for someone who was a bit less of the landlubber sort to pick up the pen.

Chapter 1

The Beginning Years

The area that we now know as Stamford, Connecticut, originally went by the name of "Rippowam," which had been given by the Native Americans who first prospered there. As the Europeans began to discover the region, they continued to use "Rippowam" until April 6, 1642, when it was officially changed to "Stamford." It is believed that the choice of Stamford comes from the English settlers' desire to honor the existing city of Stamford in Lincolnshire, England.

A formal deed to the city was signed on July 1, 1640, with the key players in attendance during that transaction being Captain Turner, representing the New Haven Colony, and Chief Ponus, who stood on behalf of the Indian tribes that occupied the New Canaan and North Stamford territories at the time. As a thank-you for the approximately seven- by eleven-mile parcel of land that ran north to south from current-day Bedford, New York, to Long Island Sound and east to west from the Five Mile River to the Mianus River, Captain Ponus accepted an estimated gift of twelve coats, twelve hoes, twelve hatchets, twelve glasses, twelve knives, four kettles and four fathoms of white wampum. As time went on, however, the Native American inhabitants realized that they could have received much more in exchange for their precious land, and ultimately a larger sum was agreed upon by all sides in 1700. From that point on, Stamford began to truly evolve as a settled community.

Agriculture was an innate characteristic of the region; settlers could produce a variety of healthy and abundant crops. The waterfront, though, turned out to be one of the city's primary sources for lucrative commerce, due to its naturally wide and easily accessible harbor, as well as its proximity to the hustling and bustling island of Manhattan. As the shipping trade industry began to grow along the shoreline, other maritime-related businesses also started to flourish. As a direct result of supply and demand, the necessity for shipbuilders, carpenters, barrel makers, sailmakers, ship store chandlers and a variety of other occupations related to yachting increased at a steady rate.

With this new influx of working coastal residents also came the need for more homes to be built along the waterfront. As the economy improved, the allure of the shoreline began extending beyond just those who made their living from the sea. Residents of New York City soon began purchasing properties in the Shippan and Cove areas, and life along the harbor was quickly becoming a major attraction within the city limits.

Mills and mill-generated businesses came to light during the late 1800s and proved to be major contributors to the growth of Stamford both economically and socially. The city's reputation was greatly enhanced domestically and internationally as a wide assortment of valuable products were shipped regularly to locations all over the globe.

Yachting exploded as a recreational activity at the turn of the century. The introduction of private clubs offering friendly sailing competitions and engaging social opportunities quickly gained in popularity. One of the most celebrated boat designers and builders in maritime history began his illustrious career along the local harbor, developing a long and impressive list of clients that included America's Cup contenders and the United States government. Magnificent ships of the era were seen daily at the shore-side docks on their way to and from exotic ports of call. A famous canal, whaling and a wartime hero all made their marks on history from where the land meets the sea at this unique corner of Long Island Sound, snugly situated between the neighboring towns of Darien and Greenwich.

The attraction of Stamford Harbor dates as far back as when the first Native Americans set up their homes along the Connecticut shoreline. Fishing was one of the primary sources for supplying food to the dinner table of the local tribes, so much of their time was spent waterside, using whatever means they could devise to bait and catch their next meal. When the settlers arrived from Europe, they, too, realized the potential of the ocean's natural supply of nourishment that was within easy grasp.

The many salt marshes that surrounded the coastal region boasted a hearty supply of cordgrass and salt hay. This proved to be ideal nutrition to feed to the local livestock and greatly enhanced the health of the farm animal population.

When international trade was introduced to the scene, vessels of all shapes and sizes frequented the local docks carrying essential products such as grain, lumber, coal, sugar, salt, beef, molasses and rum for sale or barter. As the American Revolution gained momentum, the harbor quickly became an

Enjoying a sail on Long Island Sound. *Courtesy of Hathaway, Reiser & Raymond.*

integral part of the defense plan for the region. Counterattacks and covert operations were put into action directly from the water's edge. Local vessels were called to duty as they kept a close watch on the entrance to and just beyond Stamford Harbor both day and night.

After the war ended, the harbor continued to be filled with activity. Roads and pathways farther inland were still extremely hard to traverse in those days, so travel via the water was the preferred means of transportation. New York City was close enough by boat that people readily commuted back and forth to conduct their business or to simply enjoy some well-deserved relaxation time with pristine views of Long Island Sound.

Offering ideal conditions and appealing characteristics, the Stamford Harbor was eventually declared an official port of entry by the United States federal government during the early 1800s. By 1833, a plan to construct a canal large enough to carry ships farther up the river was put into motion. As more and more commerce was being conducted with industry in the Caribbean and West Indies, it became clear that there was a need to expand

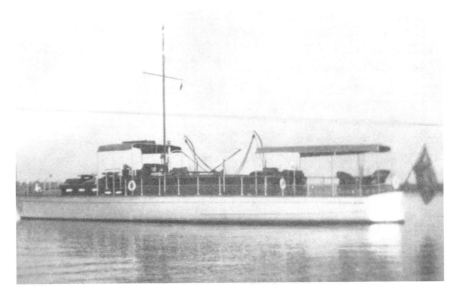

The motor vessel *Aloha*, owned by T.J. Marion during the early 1900s. *Courtesy of the Stamford Yacht Club.*

the number of working mills and factories along the Stamford shore if they were to keep up with the growing times and continue to be a contending resource. Recognizing the important role that Stamford was playing in an ever-improving national trade, the federal government approved applications by the city to make improvements to the harbor during the late 1800s.

The early years of Stamford were similar in many ways to those of all new settlements during that time. Uncertainty, dissension and the fear of failure were givens, but desire, perseverance and an ideal locale along the vast Connecticut shoreline would ultimately bring the city to a level of success unrivaled by most communities.

With the foundation now set, let us continue in our discovery of the remarkable maritime heritage that belongs exclusively to this great and historical city along the picturesque coastline of southern New England.

A Humble Lighthouse
with a Grand History

With all of the traffic that was heading in and out of the Stamford Harbor during the 1800s, the topic of erecting a lighthouse to safely guide mariners along the local shore became a front-burner issue. In the annual report of the Lighthouse Board dated 1871, officials recommended "in accordance with petition of a large number of persons interested in the trade of this port" that two beacons be constructed. They suggested that the structures be built at opposite ends of the channel, with one primarily working as a day beacon and the other one constructed as a fully lighted design. The estimated cost for both aids to navigation was not to exceed $8,000.

Although no further action was taken for nearly a decade after the initial proposal, there was eventually a renewed interest in 1880. Congress agreed to allocate $7,000 toward the project on June 16 of that year, but only for a single beacon. It was then agreed upon by Congress to provide an additional $23,000 in funds during March 1881, though still for a sole lighthouse. After careful consideration as to where to place the beacon, it was decided that a location about two-thirds of a mile from land would be appropriate. The spot they chose is what is currently referred to as Chatham Rock.

The design of the lighthouse was to follow the "spark plug" blueprint, a popular choice for Long Island Sound lighthouses during the 1800s. These unique-looking structures resemble a cast-iron tower placed on top

of a cylindrical cast-iron and concrete-filled foundation. The engineer who was commissioned for the task was a man by the name of James Chatham Duane, who worked for the Lighthouse Board. Among other contributions, Duane was involved with construction of several other lighthouses along the New England coastline, as well as a number of bridges and forts.

Once all of the formalities had been completed, the actual construction of the Stamford beacon began during the summer of 1881. The annual report of the Lighthouse Board at that time noted that "a temporary wharf was built at the site for the assembling of the iron, cement, sand, and other building materials, and for the facilities of sinking the sections of the pier."

The initial stage of the plan required that a strong foundation be laid. After creating a stable shelf from which to work, the bottom section of the tower was set in a cement plate. Next, a twenty-eight-foot-high and thirty-foot-wide cylinder filled with concrete and stone was placed on top of the base. A smaller cylinder was then added that fit snugly inside its larger component. This was to act as a basement for the lighthouse, an important aspect for beacons as it created a perfect storeroom for barrels that collected much-needed rainwater for drinking and for the containers that held coal and oil for heat. After these two cylinders were set, an outer layer made up of hefty granite blocks was added for extra protection and stability.

Then it was time for the main section of the lighthouse to be attached. This cast-iron segment boasted dimensions of twenty-two feet wide across the base and fifteen feet in height. A supplemental nine feet of solid cast-iron housed the physical lantern. Once completed, the entire tower stood forty-nine feet high.

With the structural components in place, it was time to add the aesthetic touches. For the most part, the extent of that endeavor included several coats of a rust-resistant red lead paint. The Stamford Harbor Light was officially put into service on February 10, 1882.

After initially utilizing a provisional light, a fourth-order Fresnel lens was installed. A fog bell and the most current bell-striking machinery available at the time were added to ensure that everything ran as smoothly as possible. Keepers of the light would enjoy such comforts of home as a kitchen, a parlor room and three bedrooms. The kitchen was originally surrounded by a balcony supported by stanchions and covered with a metal roof. A new, more modern design for the balcony was erected in 1927. The living space encompassed the lower section of the tower, while the watch room and lantern levels made up the top half of the superstructure. Each of the upper floors also had an exterior walkway that wrapped around the circumference of the building.

The first lighthouse keeper of the Stamford beacon was Neil Martin. Coming from a stint working at the Race Rock Light in New York, Martin lasted until the end of October 1882. His successor was a man by the name of Nahor "Naylor" Jones. Jones was a veteran of the Civil War and moved to the lighthouse with his wife, Julia. Shortly after taking his new post, Jones decided to construct a dock and bring a chicken coop to his home on the water. Soon thereafter, a damaging nor'easter destroyed the dock and the coop and sent his chickens out to sea. After that traumatic experience dealing with the elements, Jones opted to commute to and from his job from a land-based home in Shippan Point instead.

One of Jones's more memorable moments at the light came on July 9, 1884. On that fateful day, the excursion vessel *Crystal Wave* ran hard aground about a quarter mile north of the lighthouse with a full load of passengers on board. Reacting quickly, Jones set out in the station's boat and was able to safely escort the grand ship off the rocks and back to shore.

Following Jones as keeper from 1904 to 1907 was Adolph Obman. He and his wife were the first to give birth to a baby at the Stamford Harbor Lighthouse. The Obmans had five other children who were also delivered at lighthouses spanning from New Jersey to Rhode Island.

Next to take the position of keeper was John J. Cook. Originally from Denmark, Cook worked at the beacon from 1907 to 1909. His résumé included several honorable medals from his time serving in the U.S. Navy.

Cook made the local papers in May 1908 as a result of a genuinely disastrous event. At the time, his mother-in-law, Louisa Weickman, was staying at the lighthouse with Cook and his wife, Martha, when Martha suddenly took ill. Feeling that perhaps spending some time on shore would do her some good, Martha decided to go to the mainland and live with some friends for a while. Sure enough, a couple of weeks off the water did help Martha to regain her health, and she was once again ready to return to her family. Keeper Cook wasted no time in heading out to pick her up, as he immediately boarded the station's fifteen-foot launch and made his way to the mainland.

As the couple was on their way back to the beacon, the wind out of the northwest quickly picked up in speed and intensity. At about 5:30 in the afternoon, their boat was struggling to reach the lighthouse landing. As it continually kept getting caught up on rocks, Cook would step out into the knee-high water and push them free. At one point, Cook lost control of one of the oars and watched as it drifted out to sea. Maintaining his focus, Cook yelled to his mother-in-law, who had been observing the entire ordeal from

the safety of the lighthouse, to make sure that the light continued to operate properly until he was able to get back. He added that they were going to head to the dock at the mainland until the whole thing blew over and would return as soon as possible.

Just as Mrs. Weickman was about to acknowledge that she understood her son-in-law's message and would do as he asked, a large steamer ship passed between her and the tiny launch. Her initial fear was that her daughter's boat had been struck by the vessel and that the couple had been lost to the ocean.

Although she was extremely distraught, Weickman followed through on her promise to her son-in-law and kept the light running all night long. When the morning broke, there was no word as to the whereabouts of Cook and his wife. About ten o'clock that evening, a man in a boat came by the lighthouse and told Weickman that the couple had been found on Eaton's Neck in Long Island. They had been discovered stumbling on the beach, both in weakened conditions but alive. Even in his exhausted state of mind, Cook asked the lifeguard who had found them if the Stamford light was still operating. After confirming that indeed it was, Cook was able to succumb to his extreme fatigue. Soon after, the Cooks were returned to their home, to the extreme relief and delight of poor Mrs. Weickman.

In a newspaper article a few days later, Weickman shared how she felt during that horrific moment: "I have known a lot of sorrow, but I don't think I ever suffered so much as that night. I was powerless to do anything…All I could do was watch, pray and hope. Sleep I did not dream of, food I did not want."

It turns out that this would not be the only time that Keeper Cook would make it to the headlines. In December of the same year, Cook was interviewed by a reporter of a local newspaper to hear his thoughts about living at the lighthouse during the holiday season. Due to the magnitude of responsibilities that went with the job and the twenty-four-hour watch that was required of all keepers, it was virtually impossible for Cook and his wife to spend Thanksgiving and Christmas with their relatives and friends. When asked if he felt as if they were missing out, Cook replied with a rather wise and well-adjusted observation on the situation:

I dunno, it is pretty lonesome here sometimes, especially in winter, but we manage to enjoy our holidays. We can't go to church on Christmas, and we miss the nice music and the fine sermons, but there is a compensation for that. What more soul-stirring music could there be than that of wind and wave as they whistle and roar or moan and swish past our little home?

And that light aloft is a sermon in itself. Many a fervent "Thank God," many a heart-deep prayer has gone up, maybe from people who wouldn't be thinking of such things ashore, when the red gleam of Stamford Light was made out in a storm or the bell heard in a fog. My little light has its mission just as your pulpit preacher has his; and no one who has watched it through the terrible winter storms can fail to appreciate this, and with it his responsibility. Human life, yes, human souls depend upon that light Christmas and every other night of the year, and I dare guess it's compensation for the loss of a Christmas sermon to keep the light burning steadily.

Cook added that due to typically erratic weather conditions and traditionally unpredictable seas, he and his wife made it a point to do all of their holiday shopping earlier in the season than most people. That included planning the Christmas dinner menu and shopping for all of the groceries well in advance. Although it was just the two of them at the table, their dinners never reflected that it should be any less casual than a feast for twenty. Cooked goose, mince pie and plum pudding were regular dishes that the couple enjoyed before sitting down to play cards, read a favorite book or simply indulge in some good old-fashioned conversation.

Taking over for Cook in 1909 was former keeper Obman. Obman's second term at the Stamford light would last until 1911.

Winter months just outside the harbor entrance were always a challenge. To see a thick coating of ice surrounding the local beacon was a common sight. However, to see the harbor actually freeze over was, indeed, a rarity. Just before New Year's Eve 1917, an extremely frigid cold front hit the Connecticut shoreline and decided to stay around long enough to completely solidify Stamford Harbor. An article in the *Stamford Advocate* newspaper had an interesting perspective on the unique winter scene when it announced that "[m]otoring to the lighthouse is the latest winter sport." Sure enough, old Model Ts were seen testing their motor skills as they raced against one another around the lighthouse and back to shore.

One of the beacon keepers during the 1920s was Edward Iten. Iten's daughter, Florence, remembered in later years how she and her brother, Charles, used to enjoy playing on the buoys that surrounded their waterfront home. She also recalled one particular Christmas when her father decided to play Santa Claus. Apparently, Edward dressed himself up in a red suit, packed a sack with presents and ensued to climb the ladder along the side of the beacon. His plan was to deliver the gifts while his children were

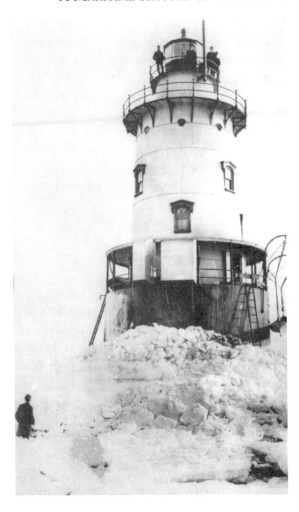

A frozen-over Stamford Harbor Lighthouse after the unforgettable blizzard of 1888. *Courtesy of the Stamford Historical Society.*

occupied doing other things and then disappear into the night. What he did not plan on, however, was that his children would catch him in the act. It seems that Iten was so surprised when the kids suddenly looked to see what the commotion was outside their window that he dropped his Santa bag and all of the nicely wrapped packages into the water. Although he eventually recovered most of the toys, it has been noted that some of them remained a bit soggy for quite a while.

As one could imagine, the Stamford Harbor Lighthouse has seen its share of groundings and wrecks over the years. One such incident occurred in November 1908 when the steamship *J.C. Austin* was towing a barge near the light. The *J.C. Austin* inadvertently hit a set of rocks about 150 yards

northeast of the beacon and then sunk to the ocean floor. Fortunately, there were no injuries recorded, and eventually the vessel was able to be refloated and put back into service.

Another close call happened in 1929. In a report issued by the *Lighthouse Service Bulletin* during that same year, it was noted that "Edward M. Whitford, keeper, Stamford Harbor Light Station, Connecticut, on July 4 rescued three men, a boy, and a dog from a motor boat, which had become disabled in the vicinity of the station."

A new keeper was brought over from the Stratford Shoal Light in 1930. Raymond Bliven was his name, and he was described by many people as being quite a large gentleman. At more than six feet tall and weighing in at some two hundred pounds, it would seem that they were right.

Bliven accepted the position and moved into his new home as a bachelor, having separated from his wife shortly before. On the evening of August 12, 1931, Bliven had plans to meet his friend, Charles Ford, in Old Greenwich for dinner. After making sure that the light was successfully working, Bliven headed out in the station's boat toward the mainland. For some reason, Bliven had opted to leave the vessel's outboard at the lighthouse and row to shore instead.

Bliven and Ford met early in the evening, and it was not until 10:30 p.m. that Bliven started on his way back home. Although the weather and sea conditions were presumably calm for the row back, Bliven did not make it to the beacon that night.

Two days after Bliven had left his friend, a woman who lived in Old Greenwich reported to local officials that the light was not working. When harbormaster Clarence Muzzion and his brother, Emil, went to check out the situation, they discovered that the lighthouse was abandoned, the lamp's oil was nearly empty and the light's wick had almost burned all the way through.

After refilling the lamp and restarting the light, the two men embarked on a search to find out what had happened to the keeper. It did not take long before they found the station's vessel, about a mile north of the beacon and upside down on some rocks, but Bliven was nowhere in sight.

Later that day, Bliven's body was discovered by the former mayor of Stamford, Alfred Phillips Jr., as he was cruising on his yacht. The body was floating in Long Island Sound, about half a mile southeast of where the boat had been found.

Once Bliven's body had been examined, there were a couple of theories that surfaced regarding what may have occurred on that fateful night. One

hypothesis was that the keeper had indeed made it back home but that as he attempted to climb the ladder from the boat to the beacon, he slipped and fell backward into the boat, causing it to flip over. He possibly had been knocked unconscious upon impact and then fell into the water and drowned. This was a popular presumption as to the events of the evening, as three of the rungs on the ladder had apparently been broken and replaced with thinner wooden pieces that were secured only by a piece of rope. This design would certainly limit the space available for a strong foothold, not to mention making the stability factor questionable.

Further conjecture suggested that Bliven's vessel may have run up on the rocks and that as he was trying to free himself he lost an oar, tipped the boat over, fell into the sound, was unable to stay afloat and drowned.

One puzzling fact about the whole event is that at thirty-four years old and with such a sturdy build, Bliven was in excellent physical condition. He was known to be a strong swimmer, and there was no sign of him being intoxicated. There were several cuts and bruises on his face and neck, which were not typical side effects of a fall and a drowning. Without any information to back up the idea of foul play being involved, officials had no choice but to call the incident an accidental drowning.

The last official keeper of the Stamford Harbor Lighthouse was Martin Luther Sowle. Sowle held the position from 1938 to 1953. He received a Congressional Silver Medal for heroism after exhibiting extreme bravery while rescuing a distressed vessel and its captain on October 2, 1939.

There is an intriguing tale about Sowle's assistant keeper, Andrew A. McLintock, early on in his tenure at the light. It would seem that while Sowle was on the mainland taking care of some business one afternoon, McLintock decided to make an entry in the station's log:

> *Temporary ass't keeper refuses to work…after having cleaned up the mess he made in the hall…and washing the kitchen floor, I fixed a pail with a little water in it and told him there was another little job down stairs while he was in the kitchen, and received abusive language as the answer.*

The temporary assistant keeper at the time was a man by the name of J. Marsden. Upon learning what McLintock had written, Marsden wrote his own entry: "Left Stat, to get Keeper."

More than fifty years after the incident occurred, Peter Davenport, a reporter for the *Stamford Advocate* newspaper, caught wind of the story and set out to check the facts a bit further. Upon having the chance to take a

look at the log book himself, Davenport had his own opinion about the transmissions. In an article dated July 2004, the columnist pointed out that the handwriting looked a bit unsteady and that it appeared as if drops of liquid may have dropped onto the page. Davenport went on to propose two possible scenarios: "Are they beads of sweat dripping from his brow? Or are they tears?"

Two breakwaters at the entrance to the harbor were constructed during a thirteen-month period from 1940 to 1941. The O'Brien Brothers Construction Company of New York was the contractor for the project that consisted of erecting a 1,200-foot-long wall on the east side of the channel and a 2,900-foot-long replica to the west of it. About 300 feet of water between the two walls created the new official entrance to Stamford Harbor.

The structures were made out of irregularly shaped granite blocks weighing as much as two tons apiece and were placed on top of submerged sand, gravel and trap rock. The total cost of the endeavor was an estimated $516,000.

A motion by the Coast Guard to replace the now antiquated Stamford beacon with a more updated version came about in 1939. The plan was to place an automated light more to the west of the harbor entrance. The request was temporarily denied, due to the efforts of harbormaster John J. Ryle, local officials, area yacht club members and a variety of other interested parties.

The Coast Guard once again attempted to shut down the historical lighthouse in 1952. When Catherine Frewen Barlow, a longtime resident of Old Greenwich, put together a letter to be delivered to President Truman regarding the lighthouse situation, this is what she wrote:

> *Native Sons and Daughters do not look upon it as something made of stone and steel—but rather as a friend. They have a deep sentimental regard for Stamford Lighthouse. The Lighthouse—Faithful Sentinel through the night casting its friendly beam of light over the waters of Long Island Sound. Save this grand old guardian of the Mariners from destruction!*

In her petition to the president, Barlow included reference to the many successful rescues over the years that had been performed by staff members of the light, all of whom had risked their lives in one way or another in the honor of duty. Although not all of the efforts had been featured in the news, each and every act of bravery had been acknowledged and appreciated by all those who rely on the beacon for a safe journey home.

The response from Undersecretary of the Treasury G.H. Foley was as follows:

> *The sentimental regard for Stamford Harbor Lighthouse by native sons and daughters in the area is readily understood. However, at the same time one cannot overlook the fact that the Coast Guard is not authorized by law to preserve an aid to navigation for its local or historic value.*

The reply went on to say that the ultimate decision regarding the fate of the Stamford Harbor Lighthouse had come to be "the result of careful study and deliberation of a Coast Guard Board constituted by direction of the President."

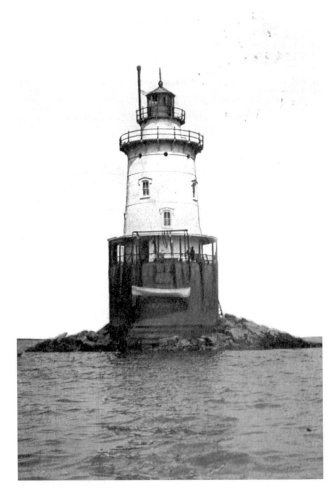

An early postcard of the Stamford Harbor Lighthouse. *Courtesy of the Stamford Yacht Club.*

Foley further recommended that perhaps an interested local party would like to take over ownership of the lighthouse in order to maintain its sentimental value to the citizens of Stamford.

An official declaration was made during May 1953 that stated that the historic light would, indeed, be retired and ultimately replaced by a new, modernized light and foghorn situated along the west side of the breakwater.

However, that was not going to mark the definitive end to the original Stamford beacon. The efforts put forth to try and save the treasured lighthouse were not completely wasted. The following month, the news arrived that a flashing green light and a foghorn would be put in service at the old lighthouse, albeit being operated from the mainland. This was good news for everyone concerned. It was also determined that Stamford resident Willard Riley would perform the new tasks of official lamplighter.

Ownership of the Stamford Harbor Lighthouse was officially listed for sale by the General Services Administration near the end of 1953. There was some interest piqued in purchasing the unique building that sits majestically in the middle of Long Island Sound in January 1954. After a few house showings to a handful of private parties, a high bid came in from a Stamford pharmaceutical manufacturer named Marvin Thompson. At the same time, however, Stamford mayor Thomas F.J. Quigley had set the wheels in motion to try and acquire ownership for the city. Quigley's argument was a good one in pointing out that it would be a great location and structure for a museum, weather observatory or civil defense post. The State of Connecticut ultimately deeded the beacon to the City of Stamford. Although the formal transaction occurred in May 1955, it was not until June 1956 that the federal government actually gave the keys to the mayor.

Interestingly, once Stamford obtained ownership, there was only a brief period of full-time focus on maintaining its integrity. The physical condition of the historic beacon quickly began to deteriorate, and by 1964, the building was again turned over to the federal government. Once in the hands of the Department of the Interior, the lighthouse was placed back on the market.

A high bid came in the latter part of 1967, this time by a group of three business partners. Commodore Benjamin Gilbert from the Stamford Yacht Club, William Schwartz and Robert Loomis (both local real estate developers) offered $10,100 for the failing lighthouse that was accepted. No one quite knew what the new owners had planned for their latest acquisition. A humorous newspaper headline stated: "Group Buys Lighthouse Without Knowing Why."

It would seem that the once popular lighthouse was having quite a bit of trouble trying to keep an owner interested long enough to bring it back

to a respectable condition. The General Services Administration once again found itself holding the title by the end of the 1960s. Eventually, the Hartford Electric Light Company took over the reins, but when it closed its doors shortly after, ownership went to Northeast Utilities. A New York bank executive by the name of Eryk Spektor ultimately purchased the lighthouse at an auction in 1984 for an estimated $230,000. "I wanted to have a lighthouse," stated Spektor in a local newspaper article. "It will be a cheap place to park my boat."

Under Spektor's care, the further depreciating beacon finally received the long-overdue makeover that it desperately needed. Spektor employed the talents of Greenwich architect Paul Pugliese to begin working on the renovations in June 1985. Once the project was completed, Spektor had invested an additional $300,000 into his new property.

Ironically, Spektor would not spend much time at his waterfront property, even after it had been painstakingly restored. Presumably, this was mostly due to the distinct lack of interest on the part of his wife in living in a lighthouse. In order to ensure that the beacon remained in good condition, Spektor hired John Weigold to oversee and care for the light.

At one point in time, Spektor considered renting the lighthouse to guests to try and make back some of his money. That idea never quite made it to fruition, and in 1997, Spektor posted an advertisement that revealed his intentions. The real estate announcement painted a pretty picture: "Your Own Paradise—20 Minutes to Shore!" The asking price was $1.1 million. An added allure was the additional ten acres of submerged land that surrounds the lighthouse, which is rather untypical of most beacons.

When Spektor passed away in 1998, the yet unsold beacon was removed from the real estate listings. Although it once again went into a neglected state, there continued to be a working light at the top of the structure, flashing white every four seconds. At the time of this writing, Spektor's estate is actively searching for a new owner.

Chapter 3

The Cove and Canal Offer Unique Opportunities for the Waterfront

The city of Stamford, like many other similar towns, has innately evolved into an area consisting of a handful of subcommunities within its physical boundaries. Springdale, North Stamford, the West Side, Shippan, Glenbrook and Cove are some of those neighborhoods that all offer their own unique flavor to the allure of the city as a whole.

The area known as Cove is located along the border of Darien and was once connected directly with the settlement of Darien. Although Stamford became its own territory in 1641, it would not be until the 1820s that the distinction between Darien and Stamford would become official. In an attempt to interpret the minutes of a town meeting held on December 19, 1696, historians have estimated that there were about eighteen to twenty-nine acres that made up the Cove at that time.

What we now call Holly Pond was once the shared channel between the two territories, known back then as Noroton Harbor. The harbor was a hustling and bustling waterway hosting a variety of sailing ships at any given time.

One of the most notable vessels to dock in the Noroton Harbor in those days was a brigandine named the *Friends Adventure*. This seventy-six-ton, two-masted ship was sold in 1688 to David Weed by shipbuilder George Phillips, and it made its new home along the harbor.

Although Holly Pond directly feeds into Long Island Sound, it lost its title of harbor due to the fact that it is in reality a "gut," or narrow passage that

runs between two sections of land. When a dam was introduced, the pond became even smaller, thus acquiring the designation of millpond.

Two of the first families to be recorded as making their home in the Cove area were the families of Jonas Weed and David Waterbury. They acquired their properties in the northern section of that land during the mid-1600s. In addition to securing several acres in the northern and western areas, Waterbury continued to expand his estate by purchasing a parcel that featured a tiny cove to the north and salt marshes to the west. For a long time, that area was called Waterbury's Island. Today it is known as Weed Circle.

Waterbury eventually filled in the salt marshes, thus making them a solid part of the mainland. The western side of the property faced Bishop's Cove, named after Stephen Bishop, who had purchased the land in 1686. Bishop ultimately sold his property to a weaver named Thomas Talmadge in 1710. Both owners had interest in that property because of its natural supply of oyster beds and sedge, a strong grass that could be used as hay or in the design of household items such as chairs and mats.

As more and more settlers were discovering the allure and potential income of living along the shoreline, Weed and Waterbury quickly found themselves in the company of new neighbors. Among them were many relatives of the families who would either purchase or have some of the land deeded to them. Sons, daughters, cousins, uncles, grandfathers and even great-grandfathers would bring not only the immediate family to Cove but their extended family members, as well. Mostly, the original surnames would remain on the deeds, but eventually the extensions would reflect a more eclectic neighborhood.

Up until the early 1790s, most of the land transactions involved only the north, south and east sections of the Cove. Just before the turn of the century, however, the Cove would begin a dramatic and influential change.

John William Holly and William Fitch were both young settlers who were drawn to the natural allure of the Stamford waterfront. They were also brothers-in-law who each saw the unique commercial potential of the mostly untouched seascape. Having already experienced success with a few small business ventures together, Holly and Fitch were ready to take on a new challenge. After extensive deliberation, the two men decided to purchase three acres of property from Jonas Weed Jr. along the Cove peninsula. Interestingly, the three acres were not connected—one was near Bishop's Cove, the second was on the southwest side of the "gut" and the third was located at the southeast corner of the "gut."

With a plan in mind, Fitch attended the town meeting on August 18, 1791, announcing his request to construct a milldam across the "gut." He said that

the entire project would probably take about seven years but that during that time he would keep the other residents of Cove notified of his progress and any potential inconveniences. Fitch said that he would always allow access to the shellfish population within the area under construction to his neighbors and that he would "at all times keep a good scow in the millpond sufficient to carry six hundred bushels of grain." In addition, Fitch promised to build a wharf that would be available to local residents and that he would take care of any damages that may be incurred during the building of the dam. At a follow-up meeting on August 22, the board voted unanimously to approve Fitch's proposal. The State of Connecticut also granted Fitch a patent for the blueprint of his new dam.

Fitch's brother-in-law ensued to purchase four and a half acres in the Cove area in November of that same year. The substantial acreage covered the entire northern section of the peninsula.

Although Fitch's initial proposal was to erect the dam along his own property lines, it would turn out that Holly's land acquisition offered a more ideal locale.

Fitch and Holly recruited two of their friends, Daniel Cotton and James Greenleaf, to help with the project. The four men went to work, utilizing "hand-hewn chestnut logs" and "hickory pegs" or "tree nails" to hold the dam together. Placed at the tip of the mainland, this original dam successfully operated well into the late 1800s.

The success of the dam was a direct result of the hard work and exceptional preconstruction preparation of Fitch and Holly. The two men had acquired some previous experience as to the inner workings of a mill during the early part of their professional careers. Understanding the dynamics of such an involved configuration was key to completing the job. They both knew that the running of the tide was essential in turning the large water wheel, which in turn would rotate the buckets that were secured to it for collecting water. As the wheel rotated, it would effectively turn a shaft that ran through to the highest millstone located at the top of the building. That particular millstone was positioned in such a way that it never made contact with a second stone that was embedded in the floor. Both millstones were made from local stone collected by the settlers and were about five feet in diameter. As the tide would ebb and flow, the millstone would complete an average of 120 turns per minute. With the process in motion, corn, rye or wheat grain was then carefully fed from a hopper into a hole, or eye, in the upper millstone. Once it had gone through the eye, the grain would be cracked and crushed by notches and

edges created in the surface of the millstones. With the constant running of the mill wheel, these edges had to be sharpened on a regular basis. The person chosen for the task did not have an easy job of it, as the stone itself weighed nearly a ton. Once that was moved enough to reach the notches, it was a time-consuming job to chisel away with a hammer and a pick until they were once again pointed enough to be productive.

After the grain was completely ground up, cornmeal was poured through a strainer, with the remaining rye or wheat blend being sent through a cylindrical frame covered with cloth. This was called a bolter. Depending on how fine the cloth cover was, the resulting flour mixture would be equally as fine.

When the mill was running efficiently, workers could expect to be packing close to four bushels an hour. Since that was just about the limit for one wheel to turn out during one tidal flow, Holly soon realized that by adding more wheels, he could easily increase his daily output.

With business booming, Holly and Fitch pursued to acquire several more parcels of Cove land. Before long, the two entrepreneurs owned almost the entire waterfront property on the peninsula.

When the two entrepreneurs were not busy at the mills, they would spend their free time with their families, taking advantage of the many wonderful recreational opportunities that abounded along their unique point of land. Swimming, boating and exploring the waterfront and Long Island Sound were favored pastimes.

Always thinking about ways to expand and improve their business, Holly and Fitch eventually decided to sell off shares of their property to interested investors. Holly sold a quarter of the rights to the road that ran through his property along with just over an acre of mill land in 1794 to James Greenleaf of New York City. A similar deal was made with Daniel Cotton, also from New York City. Cotton eventually transferred his right back to Holly, who in turn found another buyer in New York resident John Townsend.

When Townsend purchased another share from Holly, he became one of the major holders in the flourishing mill business. After paying Holly an estimated $4,000 for the additional interest, Townsend claimed rights to two mill buildings, the land they stood on, the wharf, the materials within the two mills, the milldam and a substantial section of the roadway.

At this point in time, Fitch had opted to sell all of his Cove properties in order to pursue other interests in New York City. Holly and Townsend each bought part of Fitch's estate.

Greenleaf, meanwhile, decided to cash in on his property and sold all of it to a group of Boston businessmen in December 1796 for about $8,000. This

was the first time that a reference to the land being called the Columbia Mill was recorded, and it appeared as so in a variety of following deeds.

After acquiring yet another parcel of land from Robert Lennox for about $7,300 to add to his already extensive estate, Townsend became the majority landholder in the area. With three-quarters of Cove now belonging to Townsend, Holly retained just one-quarter of the original purchase.

Not one to sit idle for too long, Holly ensued to obtain an acre of land that boasted a natural spring running through it on the western edge of Bishop's Cove. After the turn of the century, he went on to secure another twenty-one acres, which made him the major landholder of the upper half of Bishop's Cove.

Just about that time, Townsend and Holly decided to partner in a new gristmill venture. The idea was to erect another dam that would run across Bishop's Cove and also cut through the land that ran at the head of the Cove. This would allow for a steady flow of water from Long Island Sound, creating even more water power to generate their new mill. An interesting side effect of this project was that by doing so, the tip of the peninsula would become an island in and of itself. Today that section is known as Cove Island Park.

As one can imagine, this created a seemingly limitless opportunity for new jobs. The need for housing for the growing number of millworkers quickly became a priority. Two homes were immediately constructed just north of the gristmill, one of them essentially being a double house.

With the mills and the Cove section of Stamford now growing in leaps and bounds, it was beginning to attract the attention and curiosity of not only other residents of the city but also those who came to visit on their way to other destinations. One such person was writer Timothy Dwight. After spending several days in Stamford during the early 1800s, he penned the following in his literary work entitled *Travels in New England and New York*:

> *The third (interesting section of Stamford), named the Cove, is on the western side of Noroton River. On this spot, in very advantageous situations, have been erected two large mills for the manufacturing of flour and a small village, or rather hamlet, for mechanics of various kinds. The view of the harbor in front, the points by which it is limited, the small, but beautiful islands which it contains, the Sound, the Long Island shore, a noble sheet of water in the rear, the pleasant village of Noroton, and the hills and the groves in the interior is rarely equaled by scenery of the same nature, especially when taken from a plain scarcely elevated above the level of the ocean.*

Although the concept for the latest mill project was an excellent one, it soon became painfully evident that Townsend's business sense may not have been quite as ideal. With perfect work conditions in place, Holly could not understand why they were beginning to lose money. Townsend was also showing signs of not keeping up his share of the maintenance responsibilities. Certain aspects of the mill started to fall into extreme disrepair. In order to try and save the mill from completely going under, Holly took action against Townsend in 1812 to foreclose on his part of the land and business holdings. In the months leading up to Townsend's ultimate separation from the company, he scrambled to try and recover monies that he knew he would surely lose by the end of the ordeal. Since Holly had no official say on what Townsend did with the properties he still owned outright at the moment, Townsend brought in a few investors from Boston and New York. Once Holly successfully removed Townsend from all deeds, the additional investors were still involved. Holly worked around that issue by acquiring yet one more parcel of land, ultimately giving him nine-sixteenths ownership. In other words, Holly ideally became the majority shareholder.

Holly's mills continued producing for several years, and he gained the respect and status deserved of a hardworking, successful man. By the early 1830s, the original equipment used in the mills was beginning to become outdated. In an effort to modernize the process, Holly sold most of the old gear. Holly also had another business idea that he was working on at the time. An advertisement he placed in the *Sentinel* announced: "Wanted immediately two good hands in preparing Dye Woods. Constant employment will be given to such. Apply to John W. Holly, Stamford (Cove)."

Clearly, Holly's business interests were changing. Some have speculated that this new endeavor was sparked by observing the success that Sanford brothers Henry J. and John C. from the Greenwich-Rye area were experiencing in dye extract manufacturing. By improving the quality of machinery in his mills, Holly would be able to make the transition to produce a new, fresh and highly lucrative product.

During this time, an official map and geodetic survey of the Stamford coast and shoreline were being completed. The map would be the first detailed rendering of the region. It was so comprehensive, in fact, that it featured two wheel-like symbols depicting the mills, the buildings that stood on the land and the residential homes that surrounded the property.

The Sanford brothers' dye extracting business began to grow in the mid-1830s, allowing them to start purchasing land in other towns, including Stamford. One of their acquisitions included the property shares owned

by the Boston and New York partners of Holly's land. By the end of the transactions, the Sanfords owned seven-sixteenths of Holly's mill land.

Holly was in his early seventies when this was all going on and was beginning to show signs of age. Holly accepted an offer by the Sanford brothers in January 1837 to lease his share of the mill properties for one year, with the option to renew the following year. Holly passed away on September 23, 1837.

John William Holly spent most of his entire adult life living in and developing the Cove section of Stamford. A savvy businessman, Holly had a natural ability to envision something better than merely what he saw in front of him. He earned respect from his neighbors and fellow townspeople and brought the opportunity for employment to many residents. Although the mill properties were managed by the Sanford brothers at the time of his death, Holly's estate still owned the rest of the island.

Upon settling the family estate, Holly's son, William Welles Holly, sold his father's share of the mill property to the Sanfords for an estimated $7,250 on June 18, 1842.

Near the end of the 1840s, the Sanfords found themselves entering a new era that would come to be known as the Industrial Revolution. What was once a family-run enterprise soon became a joint stock company. The business of processing "dyewoods, dye stuffs, drugs, spices, plaster, extracts, minerals, clays, and paints" went public, offering a capital stock worth about $50,000. After successfully sealing the deal, the Stamford Manufacturing Company officially came into existence—it not only included the Cove mills but also the many other mills in the area owned by the Sanford brothers. The five company directors elected were Henry Sanford, John Sanford, Rollin Sanford, Isaac B. Redfield and Nehemiah Brown. Additionally, Henry Sanford held the positions of president and treasurer, while Rollin Sanford took on the responsibilities of secretary.

Shortly after the Stamford Manufacturing Company was created, the East Mill and the West Mill were in full production mode. The East Mill primarily focused on the production of Peruvian bark for medicinal purposes. (Quinine is derived from Peruvian bark, aiding in the treatment of malaria, fevers and stomach ailments.)

The West Mill, which was located at the end of the Cove area where large ships were able to dock, put its efforts toward the extraction of haematoxylon from logwood. Grand vessels arriving from Central America and the West Indies delivered the hard, brownish-red heartwood to the tiny mill. After being removed from the cargo holds, the wood was then chipped away into

small pieces and put into large vats for processing. The red, blue and black extracts that resulted were excellent for use as dyes in wool, silk, cotton and leather. Most of the dye was then shipped to New York City and various other ports throughout the United States.

With all of the new business and shipping traffic that was being brought to the humble Stamford shoreline, it soon became clear that expansion of the waterfront area would be a good idea in order to accommodate the growing commerce. Creating more room in the harbor, adding additional dock space and constructing extra mills to handle all of the order requests were realities that could not be ignored if they were to keep up the pace. The Sanfords sought, and received, a key adjunct from the City of Stamford that allowed them to gain extra water power by drawing from the nearby Noroton River. To accomplish this, water pipes were placed that ran from the source near Waterbury's Island down to the mills at the southern end of the Cove peninsula.

In addition to owning the various mills, docks and surrounding waterfront properties, the Stamford Manufacturing Company owned a fleet of vessels that included the schooner *General Lafayette* and the steamboat *Constitution*. Within a couple of years, the Sanford's business venture tripled in value and was not showing any signs of slowing down. The Stamford Manufacturing Company designed an official seal for the packaging of its products that reflected a dock scene composed of barrels and chests, with the name of the company imprinted around the edge. It was a very impressive design that successfully caught the eye of passersby, making it an easily recognizable business no matter where its goods were found. (An interesting sidebar is that after the first group of seals was printed, it was learned that the "t" had been inadvertently left out of the word "manufacturing." Obviously, the printers had to start again from scratch.)

Business was, indeed, booming and continued well into the 1850s. However, it has been noted that a rather large and intense fire occurred about 1855, although there does not appear to be any specific mention of it in the Minute Book for that year. The recorded dividends were quite a bit lower than had been seen over more recent months, which some believe was an indication of the extensiveness of the damage caused by the blaze.

Another odd fact about the presumed fire is that any copies of the local newspaper for that day are, evidently, nonexistent. The closest reference as to what may have happened on that fateful day can be found in a story published in the August 31 issue of that year titled "The Workmen at the Cove Mills." It reads:

Cove Island, Shippan Point and the Stamford Harbor Shoreline

We are informed that our statement in regard to the workmen at the Cove Mills being thrown out of employment in consequence of the destruction of the works by fire was erroneous. The (mill hands) are all employed in getting the mills into operation again.

The specific events and details of the fire may never be known, but the productivity of the Stamford Manufacturing Company did not appear to suffer too much from the incident. During the 1860s, the company boasted a reputation that stretched to an international audience. What had started out as a local business now serviced clients all over the globe, making the Stamford-based company one of the largest dye extract sources in the world.

The inventory produced from the local mills included other products as well, such as ground and bleached minerals that were becoming a popular and valued commodity for a variety of usages. The company began purchasing mining property farther into the state, but after about ten years, the resources were depleted.

This was also about the time that the Civil War was beginning to gain momentum. Expenses began to get a little tight at the mills, as they did with every other type of business during that time. With the war also came a state of financial depression for the country, at which point sections of the mill lands began to be sold off.

Business started to show a little improvement by the end of the 1870s. A new president of the Stamford Manufacturing Company was appointed. William Gay was now the man in charge, and he certainly proved to earn his keep. Gay put into action a business plan that included the original logwood dyes, as well as a selection of spices, flavine (a dye and antiseptic derived from black oak) and licorice. Licorice quickly became one of the more popular items. Its use was expansive, including being prescribed as an expectorant and laxative, as part of the brewing process, as flavoring in tobacco and as a candy. The licorice market was so promising, in fact, that the Stamford Manufacturing Company was importing an estimated 500,000 pounds of licorice root each shipment!

William W. Skiddy, Gay's son-in-law, joined the company at the beginning of the 1880s, bringing some solid business savvy to the table. Aware of the fact that the level of competition both locally and abroad was improving, Skiddy came up with some fresh ideas to help revitalize the existing business plan. Skiddy suggested that the company consider upgrading the mill machinery, start looking at alternative ways to process the licorice root and focus on expanding its international market exposure. To achieve these proposals, the

company invested in new cylinders and updated boilers, modern extractors, macerators, brew cutters and mullers. Additional sheds, larger vats, a coal dock and a hoisting engine were also brought in. New water pipes were installed, the buildings were renovated with brick (to avoid potential fire damage) and property that was not being used was sold off.

A joint stock company named the Cove Transportation Company was formed in the mid-1880s to help manage the large freight business waterside. The company's boat fleet consisted of four schooners: *Ida Palmer*, *Robert A. Forsyth*, *Oscar C. Acken* and *Samuel P. Godwin*. Other great ships of that time period that were seen regularly in Cove Harbor included *Citizen*, *Oliver Wolcott*, *John Marshall*, *Nimrod*, *Fairfield*, *Croton*, *American Eagle*, *Cricket*, *Cataline*, *Fraser*, *Ella*, *Stamford*, *Shippan*, *P.C. Schultz*, *Olyphant*, *Osseo*, *Americus*, *Nelly White*, *Meta*, *Harlem*, *Alert*, *Shady Side*, *Duncrag*, *Edgar Ross*, *Brookside*, *C.D. Pickels*, *Vitalia* and *Van Wyke*. These massive and magnificent vessels could carry seemingly limitless amounts of freight, cargo and passengers in all types of weather and at all times of the year.

While things were developing nicely on the Cove side of Stamford, there was much going on along the shoreline at the other side of town, as well. With manufacturing the primary source of commerce for the city, more and more factories were being built at every niche and corner that could be found. Obviously, with the local waterways providing the main mode of transportation at the time, the harbor and the entrance to it were constantly filled with boating traffic. Ships came and went at all hours of the day and night, and even with a substantially sized natural harbor, businessmen realized a need to expand the existing waterway access.

A proposal to build a canal that would run to the center of town along the east branch of the harbor was put into action in the early 1830s. Alfred Bishop was a key player in accomplishing this massive undertaking, and under his tutelage, the canal was successfully completed in 1833.

During construction, new warehouses were erected along the extension by Atlantic Square. This was one of the main ports in the harbor, as schooners and sloops would set sail or tie up at the dock at this point on the route. The canal, which was located directly under where the current-day Canal Street runs (hence the name), remained a vital part of the local economy until 1868. At that point in time, a section just north of the railroad was closed, and an effort to make the channel wider and deeper to that tract became a priority. With financial support from J.B. Hoyt, J.D. Warren and a handful of other investors to back up the project, workers began dredging at specifications of an additional nine feet down and eighty feet to either side. Once this

was accomplished, it added even more potential to the already thriving shorefront. An article in the tercentenary edition of the *Stamford Advocate* had this to say about the expansion: "The canal was a great movement towards prosperity and many industries sprang up along its banks, attracted by the availability of the shipping lanes."

Gay continued performing productively in his role as president of the Stamford Manufacturing Company until 1882, at which point in time he stepped down and allowed W.T. Minor to take over the responsibilities.

William W. Skiddy then succeeded Minor in 1889 and ultimately took the company right through to the end of its era in January 1918 as being one of the largest and most successful manufacturing companies in the world at that time.

To try and salvage what little was left of the demised corporation, Skiddy transferred the deed to a new company named the Stamford Extract Manufacturing Company. The succeeding business did not fare well, as one could probably have presumed from the closing of its forerunner. With yet another company folding imminent, the final end actually came by means of a devastating fire on February 19, 1919. The blaze broke out at about seven o'clock in the evening on that fateful day. The flames were so intense that they "lit the sky so that people gathered from some distance and many remember the awesome sight."

There was a full northwest wind blowing that night, which certainly did not help matters. The fire departments stood virtually useless in the glow of the disaster. In an article published in the *Stamford Advocate* the following morning, it was suggested that some $2 million had been lost and that the event had been the most damaging fire in the history of Stamford to that point.

An interesting and important event in international history occurred at the Cove in 1914. An English ship by the name of *Pass of Balmaha* had come to local waters during the onset of World War I. After staying at the Cove docks for six months, it was decided to change its registry from England to America. This unique international act was to set the precedent as being the first foreign vessel to set forth from Connecticut under the American flag. Sadly, though, upon one of its departures, it was captured by Germans, who claimed the vessel as their own, renaming it *Seeadler*.

In addition to being a focal point of local commerce, the Cove was also developing as a residential and recreational destination. Eeling, crabbing, swimming, boating and simply enjoying relaxing afternoons along the shoreline innately drew people to the area. During the cold winter months,

The sailing vessel *Tinic* cruising on Long Island Sound, circa 1936. *Courtesy of Hathaway, Reiser & Raymond.*

the pond typically froze over enough for ice skating, sleigh racing and even horse racing. There has been reference to a one-hundred-mile race that was held over the Christmas holiday season in 1893. Whether those miles were logged simply by circling the old millpond round and round again or if they had ventured beyond the edge of the harbor to complete their competition is unclear. What is certain is that contests such as these were fairly common practices during the latter part of the 1800s and into the early 1900s.

Today, the area of Cove and Cove Island Park continues to flourish as a vital subcommunity within the city of Stamford, offering a variety of leisure and entertainment activities, as well as exceptional living opportunities along picturesque Long Island Sound.

Chapter 4

Shippan Point

Farmland, Summer Resort and American Revolution Home Base

When you drive or sail by the shoreline of Stamford, you will notice that there is a distinct peninsula that extends out from the harbor. This unique piece of land is located at the southernmost tip in Stamford and offers one-of-a-kind views from all three sides of picturesque Long Island Sound.

This particular section of Stamford was initially given the name of "Shippan," and its origin is believed to have come from a similar Indian word meaning "the shore where the sea begins."

When the first settlers arrived, the soil along the peninsula proved to offer ideal conditions for the harvesting of corn. From the mid-1600s to the turn of the century, the property was divided into what was known as "five rail fence"–sized lots. The landowners of these lots spent most of their time tending to their crops. Town meetings became regular events, and during one of those assemblies it was decided that the lots would be divided with more specific boundaries. Most of the homes had very definitive property lines by the late 1700s.

A few of the family names that were acquiring properties in Shippan at the time were the Ambers, Beldings, Jaggers, Hoyts, Weeds, Pettits and Waterburys. At the very end of Shippan Point was an area referred to by the locals as Belding's Bluff. At one point in time, the owner, Benjamin Belding, claimed more than one hundred acres of land as his own. When Belding

passed away in 1741, his family sold a section of the property to a shipowner by the name of John Lloyd, who was the proprietor of a popular general store located at the mouth of the Mill River. His family was one of the wealthiest ones on Long Island Sound, which is evident in the fact that they owned the area of Long Island that we now know as Lloyd's Neck.

An interesting story about Lloyd's Neck is that during the American Revolution it was occupied by British soldiers. During a historic event that occurred on September 5, 1779, Colonel Benjamin Tallmadge led 130 of his men from Shippan Point to Lloyd's Neck in an attempt to capture the British forces. To properly appreciate the extreme seriousness of the American Revolution along Long Island Sound that led to that fateful night, one must first understand the series of events that ultimately led up to the unforgettable incident.

In the book *The Story of Stamford*, author Herbert F. Sherwood shares his interpretation of what may have happened during that time period along the Shippan coastline:

> *The proximity of Long Island Sound gave the patriots of Stamford an opportunity to show their devotion to the Revolutionary cause. The enemy often sent vessels of war, as well as merchantmen, up the Sound from New York. It devolved upon Stamford, so near the debatable ground, to assist in keeping the waters of the Sound clear of such unwelcome visitors, always full of menace to the towns further east. Many daring deeds were performed by Stamford's boatmen. One of the most courageous of these was Captain Ebenezer Jones. A story of one of his exploits has come down through the years.*
>
> *One day information came that a frigate and a sloop of war belonging to the enemy were lying in Oyster Bay, across the Sound. Captain Jones determined to take the sloop with his whaleboat fleet.*
>
> *Shortly after midnight he, with his little flotilla, started across the nine-mile stretch of water. He saved the strength of his men as much as possible by making use of the light wind, but this fell before daylight, and they were obliged to row into the harbor. A fog had settled down over the bay, which helped the boatmen. Discovering the sloop's anchorage, Captain Jones rowed around it in the early gray of the morning without being seen.*
>
> *He was at length discovered, just as he got close alongside, and hailed:*
> *"Who's there?"*
> *"A friend."*
> *"A friend to whom?"*

"I'll let you know," responded Jones, as he clambered over the side of the sloop. "The rebels have been rowing around the bay all night, and you've known nothing about it. I'll report you for neglecting your watch."

By this time the men from the boats were climbing up the sides of the vessel. Jones continued storming away at the officer of the deck for his negligence, while the officer, thinking that he had run afoul of some violent old Tory, who would report him to his commander, trembled from head to foot. He assured the rebel captain that the strictest watch had been maintained, and begged him to notice the order on the vessel, and to observe that the guns were trained, and the muskets in their racks ready for use. A number of these muskets were already in the hands of Jones' men.

Stamping heavily upon the deck, the prearranged signal, his boatmen crowded around, and the sloop, with her score of guns, was in their possession.

About this period another vessel was captured in broad daylight by whaleboat men in the narrows below. The crews of some of the boats climbed over the sides to the deck, while from one, whose rudder had been shot away, the men entered the cabin windows under the stern, and met the crew of the British vessel, driven below by men from the other boats. After a short and desperate fight with broadswords and bayonets in the cabin the crew surrendered and the vessel was taken to Stamford.

Among the most important and exciting forays organized with Stamford as a base were those conducted by Major, afterwards Colonel, Benjamin Tallmadge. Tallmadge was one of the dashing figures on the American side of the war. Born at Brookhaven, Suffolk County, Long Island, on February 25, 1754, he was only twenty-one years of age when the Revolution broke out. His father, the Rev. Benjamin Tallmadge, was the settled minister at Brookhaven, while his mother was the daughter of the Rev. John Smith of White Plains. Following in the footsteps of his father he entered Yale College in 1769 at the age of fifteen years. He received his first degree and was Class Orator in 1773 at the age of nineteen. On leaving Yale he was appointed to the charge of the high school at Wethersfield. He was here when the war broke out. Captain Chester of Wethersfield, a friend, having been appointed to the command of a regiment of Continental troops, offered him a commission as lieutenant with the duties of adjutant. The offer was eagerly accepted. His commission, signed by Governor Trumbull, bore [the] date of June 26, 1776.

An adjutant's duties were too tame for so ardent a spirit. He became increasingly serviceable to the American cause in conducting special

expeditions calling for speed, resourcefulness, and quickness of decision. He was only twenty-five years old when, in 1779, he brought about two hundred British and Tory prisoners from Lloyd's Neck, Long Island, into Stamford with a force of only one hundred and thirty men. One of his most useful services to the country was that which through his quickness of perception of a situation led to the prevention of the escape of Major Andre, while the latter was on his way to the British lines and New York with the papers given to him by Benedict Arnold for the transfer of the key fortification of West Point to the British. Andre had been found by three men at Tarrytown, N.Y. on his way south. Lieutenant-colonel Jameson in command of the camp at North Castle failed to recognize the significance of this capture and the Adjutant-general of the British army was being forwarded to General Arnold. The early return of Major Tallmadge and his prompt recognition of the importance of the prisoner led to the latter's being brought back to camp. This prevented the possible release by Arnold and the probable transfer of the fortification and the command of the Hudson Valley to the British. The fortunate arrival of Tallmadge led to the detention of Andre and his subsequent conviction as a spy and his execution. Tallmadge had close contact with Andre until he was hung. He became much attached to this lovable young British officer, as did other American officers who came to know him.

The successful capture of the Tory raiders at Lloyd's Neck was among the more brilliant and dramatic of the minor achievements of the war. Major Tallmadge, who was honored with the special confidence of Washington, formulated the plan for capturing the marauding Tories and put it into execution by bringing together on Shippan Point on the night of September 5, 1779, a body of one hundred and thirty picked men. A supply of suitable boats had been drawn up on the strand in readiness for the expedition. It was just becoming dark when at eight o'clock the men entered their boats and started across the Sound. It required only two hours to reach Lloyd's Neck where the enemy was so completely surprised that he surrendered with practically no resistance. The number of boats brought along was sufficient to transport all the prisoners back across the Sound to Stamford where the expedition landed about daybreak without losing a single man.

In the course of the succeeding years of the war, Major Tallmadge continued to conduct similar dashing exploits across the Sound with almost equally notable results. Two of these had their bases at points east of Stamford, but one of the most ambitious was that planned for December 7, 1782. In the fall of 1782 a considerable number of British light horse with

a force of infantry had established quarters at Huntington, Long Island, for the winter. Tallmadge, now a colonel, obtained a personal interview with General Washington with the object of gaining permission to organize and conduct an expedition against the enemy at Huntington. This was granted by Washington on condition that the plan should not be carried out until he had communicated the exact date on which the attempt should be made.

Colonel Tallmadge assembled a force of seven hundred men on the west of Shippan Point approximately where the Stamford Yacht Club now stands. In order to assure the success of the project, which came to light later as a part of a plan of Washington for attacking the British in New York, it was necessary that the troops to be utilized by Tallmadge should not assemble at the place of embarkation until the date of its execution. It appears that it was Washington's intention to throw a large detachment of his army below Fort Washington on Manhattan Island while the main body moved down to Fort Independence and King's Bridge. In the meantime Colonel Tallmadge's raid on Huntington would keep the British forces at that point occupied and prevent them from joining the main body in New York. This was the reason for delaying the execution of the plan until the date assigned by General Washington. In due course word was received from Washington naming the night of December 7.

On that evening the different detachments detailed to serve in the expedition met for the first time in the vicinity of Stamford. They moved from Stamford down to Shippan Point where Tallmadge had ordered the boats to be in readiness. Upon arrival at the shore and observing the number of boats, the officers of the different detachments began to suspect that a considerable enterprise was in view. The entire force had assembled on the shore before the sun set. The weather was somewhat severe, so he ordered the little army to parade where the boats were drawn up. The platoons were assigned to the different boats but before one half the troops had embarked, Colonel Tallmadge observed a squall of wind arising from the west accompanied by rain. Its violence made it necessary to halt and disembark the men. The wind and rain, mixed with snow, were so violent that the boats were drawn up and turned over to serve as shelter and protection. The storm cleared by morning but the Sound was so rough, being a perfect foam, that it was felt no boat could live in it or keep above water for more than five minutes. The wind continued throughout the day abating, however, somewhat, at sunset so that the troops again were ordered to parade. A few of the boats were launched, but the wind rising again they were not put to service. The second night was spent in the same manner as the first.

The following day Colonel Tallmadge received information that three boats from Long Island had taken refuge on one of the Norwalk islands a few miles to the eastward, windbound and unable to return. Later in the day the wind and sea smoothed down somewhat. The enemy's boats appeared on the Sound returning to Long Island. Colonel Tallmadge ordered six of his best boats with sails to be manned. Captain Brewster, an experienced sailor, was directed to seek out the enemy and if possible capture the boats. The boats put off. Although their course was before the wind three of them found it necessary to return. The enemy, observing three boats bearing down upon him, pressed all sail as well as oars. Captain Brewster steered his course so judiciously that before the middle of the Sound was reached he fell in with two of the enemy's heaviest craft and engaged with great fury. The first fire felled every man in one of the boats, either killed or wounded. Captain Brewster himself received a ball in his breast which passed through his body. However, he captured two boats, only one escaping. Although he was supposed to be mortally wounded, he recovered, and lived to be nearly eighty years of age.

On the third night, still anxious to carry out his plan, Colonel Tallmadge once more made preparations to embark the troops. Again the wind rose furiously. In view of the fact that one of the enemy's boats had escaped and had probably given information that a body of troops was on Shippan Point, he gave over the expedition. The next day he ordered the detachment away from Shippan and marched it to camp.

The expedition of September 5, 1779, was of such distinction that there currently remains a bronze plaque that was placed on the grounds of the Stamford Yacht Club in 1915 to commemorate the historic event.

After the Revolutionary War ended, the peninsula was able to return to life as normal. The farmlands were once again being tilled and harvested, and an influx of new and wealthy residents were beginning to make their homes in Shippan.

A successful businessman by the name of Moses Rogers acquired 102 acres of property in 1799 for an estimated $8,000. Rogers would go on to purchase another 74 acres for a presumed $2,791 in 1800. Still searching to add to his Shippan landholdings, Rogers once again signed the dotted line in 1806 for the rights to the Waterbury Farm. That transaction cost about $10,000 and gave him a grand total of some 400 acres encompassing the entire southern portion of the peninsula.

Rogers had a few ideas for his newly acquired properties that he had been considering, one of which was to construct a European-style mansion along

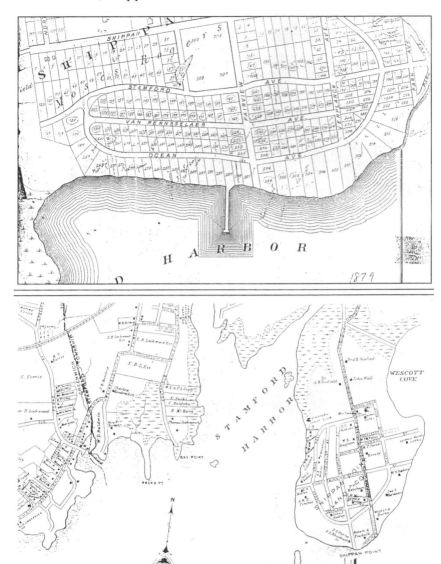

Maps of Shippan Point, circa late 1800s. *Courtesy of the Stamford Yacht Club.*

the waterfront. The site was to be located on the east side of Shippan, and it was such an impressive spot that Timothy Dwight included a description of the property in his book titled *Travels in New England and New York*, published in 1822:

Another is a peninsula on the east side of the harbor, mentioned above under the name of Shippan, the property of Moses Rogers, Esq., of the city of New York. This also is an elegant and fertile piece of ground. The surface slopes in every direction, and is encircled by a collection of exquisite scenery. The Sound, and Long Island beyond it, with a gracefully indented shore, are directly in front, and both stretch westward to a vast distance and eastward till the eye is lost. On each side also lies a harbor bounded by handsome points. A train of groves and bushy island, peculiarly pleasing in themselves, increase by their interruptions the beauty of these waters. The farm itself is a delightful object, with its fields neatly enclosed, its orchards, and its groves. Here Mr. Rogers has formed an avenue, a mile in length, reaching quite to the waters edge. At the same time, he has united plantations of fruit trees, a rich garden, and other interesting objects, so combined as to make this one of the pleasantest retreats in the United States.

Once the mansion was completed, it required someone who would be able to care for it full time. Rogers hired a man from Stafford Springs, Connecticut, named Royal L. Gay to manage the property.

After Moses passed away in 1825, his family took over the responsibility of maintaining the estate. For many years, they rented out the mansion and the other buildings that were part of the property to Isaac Bragg for an estimated $400 a year to use as a boarding school. Although part of the deal was that their tenant maintain the buildings and lawns in pristine condition, Bragg did not hold up his end of the agreement in that respect, and the estate eventually began to show signs of disrepair. The family members opted to break the lease with Bragg at that point and soon after brought in S.E. Lawrence, who was able to restore the property back to its original condition.

Once the treasured estate was up and running again, it became a popular destination for residents and guests to relax, picnic and enjoy amazing water views. On one particular summer afternoon in 1845, some five hundred visitors were recorded roaming the park area.

When Rogers's last child passed away in 1866, there were no other relatives left willing to assume the role of maintaining the property, so it was put up for public auction. At that point in time, there were several other neighborhood properties that were also going to be put up for auction. The trendy magazine *Harper's Weekly* covered the story about these preferred real estate opportunities in one of the nicest areas on the Connecticut coastline in 1869. A prospective buyer named Sally Scofield found a parcel of land

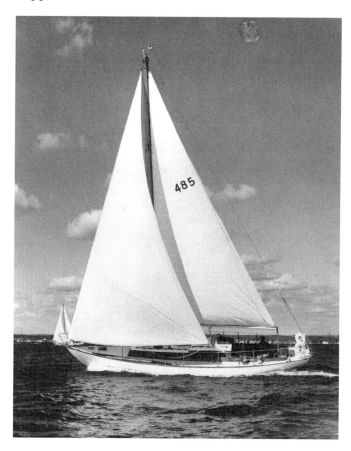

One of the regular yachts seen sailing on the Stamford Harbor horizon. *Courtesy of Hathaway, Reiser & Raymond.*

composed of ten acres in the center of Shippan Point that she liked and made a bid of $980 for it. This would turn out to be the highest offer, so Scofield became the new proprietor for an amazingly low price.

Back at the Rogers estate, the family was having difficulty finding a buyer for the exceptionally large lot as they entered the 1870s, so it was decided to break up the land into about four hundred smaller subdivisions. To accommodate the change, additional roadways were constructed. The modern-day streets of Van Rensselear and Verplanck are named after two of Rogers's grandchildren, with Rogers Street reflecting the family surname.

On the southeastern side of the peninsula, there were quite a few parcels of land that sold for about $2,000 apiece in 1885. Colonel Woolsey Rogers Hopkins, who was the grandson of Moses Rogers, bought about four of those lots. Hopkins ensued to erect a stunning mansion two years later that is now located at 192 Ocean Drive East.

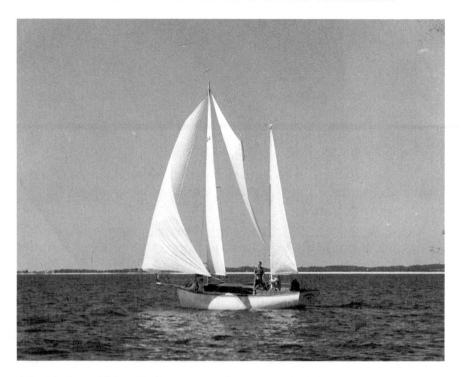

A Stamford vessel flying all of its sails to catch the best wind. *Courtesy of Hathaway, Reiser & Raymond.*

With Shippan growing in popularity as a preferred summer destination during the mid- and late 1800s, the need to build a hotel or two arose in order to accommodate all of the visitors. One of the most well known of these establishments was the Ocean House, which was completed in 1870. The Ocean House was located on the site where the Woodway Beach Club stands today.

During this time, great steamships began frequenting Shippan Point on a regular basis, carrying hundreds of passengers at a time to their vacation getaway. One of the busiest of these steamships was the *Shippan*, built in 1866 and designed specifically to transport people back and forth between Stamford and New York City. The *Shippan*, as well as the other steamers, stayed quite busy until 1873, when a fall in the market caused the economy to change drastically.

Once the market began to recover in the 1880s, Shippan Point again became a major tourist and vacation attraction. The hotels were back entertaining their customers, parks were packed with crowds of people and

the ships were running on their regular schedules. An investor by the name of Michael McDevitt (or McDeavitt) purchased the Ocean House Hotel and renamed it Shippan House. With the vision of expanding the existing amenities, by the end of the 1880s McDevitt had added a beach pavilion, bathhouses, a casino and a carousel that had once operated in Asbury Park, New Jersey.

Another bathing pavilion was constructed by John Ennis in 1887 at the southwest section of Shippan Point. The pavilion was set directly over the water, which allowed swimmers the opportunity to enjoy their favorite pastime underneath the structure without concern of burning from the sun. Playing fields and a 150-stall horse shed were also added to Ennis's property.

Ennis offered his popular piece of property that consisted of ninety-five acres of waterfront to the City of Stamford to use as a public park in the early 1890s. After many council meetings, Mayor Homer Cummings finally made the decision to accept the deal on Halloween night in 1906. Today, that area is known as Cummings Park.

The sailing vessel *Vitesse* enjoying an afternoon cruise on Long Island Sound. *Courtesy of Hathaway, Reiser & Raymond.*

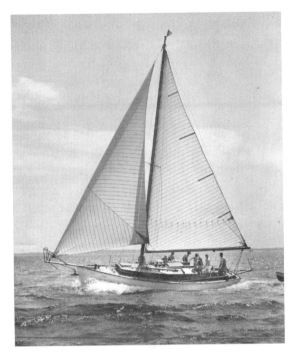

The sailing vessel *Mutiny* cruising the waters around Stamford Harbor. *Courtesy of Hathaway, Reiser & Raymond.*

Shippan Point had clearly become a neighborhood for the wealthy by the early 1900s. The Moses Rogers mansion was acquired by the Fosdick Syndicate in 1899, with the new owners choosing to rename it the Shippan Manor Company. Later, Mr. Marriott opened up the Manor School on the property, which included a three-story dormitory. The Stamford Military Academy moved into the original school in 1902. Several years later, it became the Massee School.

On the west side of the peninsula, another educational institution appeared, this time run by Miss Low and Miss Heywood. During this same time period, Leonard Barsaghi purchased the Shippan House and the casino located on the eastern side of Shippan and then ensued to make what he believed to be necessary renovations to both structures.

As the economy continued to thrive, real estate in Shippan grew more inviting. James Jenkins of the Shippan Land Company developed more than one hundred acres of land at the Point by adding landfill and constructing additional roadways about 1913. Frank J. Marion, well known as a producer of the "one reeler" silent films, purchased property in 1914 at what is now 1 Rogers Road. His unique castle-style mansion remains an attraction in the neighborhood and is known as Marion Castle. Marion Castle now holds a distinguished spot on the National Register of Historic Places.

Today, Shippan continues as a wealthy section of the city of Stamford, with outstanding water views and immaculate properties. The Stamford Yacht Club is a prominent fixture along Ocean Drive West, and the magnificent trees and fields of yesteryear are still evident as you drive along the historic shoreline.

Growing Up Along the Waterfront During a Magical Era

What a fascinating time it must have been for young children growing up along the Stamford shoreline during the early 1800s. Great ships traveling from near and far dotted the horizon and unloaded their precious cargo at the local docks. Fishing with your dad for that night's dinner, running along the beach with friends, discovering new surprises from the sea and enjoying swimming and splashing about in the fresh salt water of Long Island Sound were all natural parts of life as a child near the water's edge. It was a magical era for everyone, most of all for the junior residents of the area.

There is a wonderful glimpse of what a young boy or girl must have experienced during that time period in the book *The Story of Stamford*, written by Herbert F. Sherwood:

With a carriage and pair the Spring days offered an irresistible lure to drive to the shore for an all-day picnic. My, how you loved that! You would dig clams for the bake. You would scurry hither and thither among the rocks in search of weird little crabs and starfish caught in the tide-pools. You would lie on the hot sand in the sun, looking up at the fleecy clouds floating swiftly across the bluest of blue skies, wondering greatly about this and that until you were summoned to the feast spread out on a snowy cloth on the grass. And then you listened to the tales of sailing ships, some of them to be seen

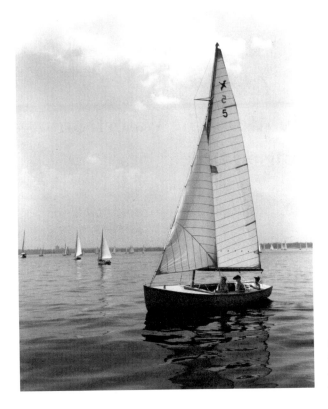

Sailing on Long Island Sound. *Courtesy of Hathaway, Reiser & Raymond.*

in the distance tacking across the wide waters of the Sound. Most of these great vessels made long and marvelous trips to strange lands and back. You would hear of the riches brought from India, wonderful cloths and shawls and ivories; of the cargoes brought from England with fine brocades and satins and linens for some bride's dowry; or from France, with models of the latest styles made in miniature for a set of dolls to be exhibited in one town after another for copying by the local dressmakers; or from China, with still more romantic and wonderful stores, perhaps a whole new set of tea dishes that might find its way to your own village and be the envy of every housewife and the pride of its happy owner. Little would you guess how that same precious set of dishes would be saved and treasured by generation after generation and eventually scattered through many homes claiming inheritance from the one you knew. Perhaps a schooner might be returning from the West Indies, out there beyond Long Island. Ah, then there would be a cargo of rare and wonderful fruits. At Christmas time you had had a golden orange all your own to enjoy and finally to taste, making the

sweet juice last as long as possible to gratify your palate. Oh, that they all *would come sailing into Captain Lockwood's Landing and not pass by to distant New York!*

Those that did come into the Landing were interesting enough, though most of them were from up and down along the shore. It was fun to watch them loaded with cargoes from your own village and go sailing off. Perhaps someone would go along as a passenger and return with the sloop days later with great tales of the trip and of the strange sights of New York or Boston. You knew from comments of the grown-ups that Stamford village was quite an important place. They recited how from all the country near about the farmers brought their crops of potatoes, apples and corn, the carded wool and cloth from the scattered fulling mills, to be carried by boat to Long Island towns or New York.

One of your most thrilling moments was when you entered one of the general stores upon a mission, the order entrusted to you thoroughly memorized. Perhaps you had been sent for some trifling notion needed in an emergency of the household. Whatever it was, you walked into the midst of a conclave, for the general store was a village club room where groups lingered to discuss matters of community and neighborhood interest. You were much too intent upon securing the article you were sent for to listen to the remarks of the chatting groups, though, of course, you politely answered their queries as to the health of members of your own family. What thrilled you was the chance you now had to look about at the fascinating things to be seen in this storehouse of treasures.

Thoughts of far lands filled your imagination as you came along the village street. Beyond this town, with its comfortable white houses, each with its tree-shaded yard enclosed with a white pale fence lay adventure. Beyond the Hudson was the land of romance to be reached only by long horseback trips; beyond the shining waters of the Sound lay the soft blue bank of Long Island from whose farthest fishing villages went the brave whaling fleets on their months—or years—long voyages. Over the vast sea sand and went the swift sailing ships to China and India and South America. These, too, would lure you, when you had finished school. In the meantime you would study and learn as much as possible, you thought, as you strode along the dusty street, your bare feet making clear tracks in the soft, warm sand, and a stray flock of geese coming marching along in file, a tempting object for a chase.

In the woods the pink ladyslipper was in bloom; the waters of the Sound sparkled under the May sun, a shower of diamonds in a sweet world; the

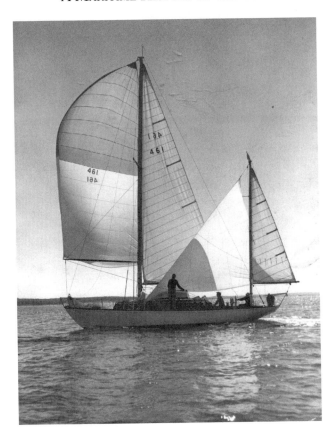

The thirty-eight-foot yawl *Katama* on its way to victory at the 1958 Fall Off Soundings Race. *Courtesy of Hathaway, Reiser & Raymond.*

fragrance of apple blossoms floated out from orchards; there was a bustle of Spring cleaning in every household; and from way down the village street came the strange, strident blast of The Peddler's tin horn, a blatant herald of Spring.

How enchanting, captivating, inspirational and thrilling those days must have been. Fortunately, if one were to take just a brief moment and truly look around the local shoreline, those same emotions can be experienced today.

The Stamford Yacht Club
Creates a One-of-a-Kind Oasis
Along Stamford Harbor

On a beautiful, sunny afternoon in May 1990, members and officers of the Stamford Yacht Club dressed in their finest nautical garb and gathered on the pristine waterfront lawn along Ocean Drive West in Shippan to commemorate the 100th anniversary of the prestigious club.

A century earlier, in September 1890, an avid yachtsman by the name of William A. Lottimer was sitting aboard his vessel *Fenella* anchored just beyond Stamford Harbor, contemplating life and enjoying the end of a day on the water.

Just about to set the sails and embark on the long journey back to the mainland, it dawned on Lottimer that he wished there was a closer destination within the inlet where sailors and cruisers could call it a day. Perhaps a yacht club of sorts would be in order, he thought. The more he considered it, the better it sounded. In addition to making it easier and more efficient for yacht owners to reach Long Island Sound, a club environment could also appeal to family members and guests—a coastal retreat where they could enjoy social activities, swimming and sunbathing along the shoreline.

With the wheels turning in his mind, Lottimer decided to invite a few of his closest sailing companions to his home on October 16, 1890, to discuss the possibility of such an organization. After presenting his proposal, it was unanimous that all were in agreement to help set forth the plans to create this new club. The Stamford Yacht Club was to be its official name.

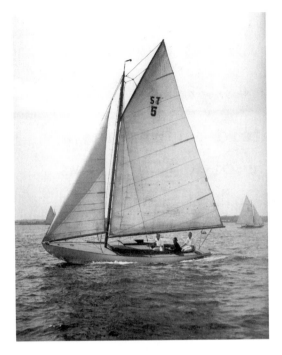

Sailing along the Stamford waterfront. *Courtesy of the Stamford Yacht Club.*

A Stamford Yacht Club "knockabout," circa 1914. *Courtesy of the Stamford Yacht Club.*

Cove Island, Shippan Point and the Stamford Harbor Shoreline

The first officers to be elected into office were William A. Lottimer as commodore, Samuel Fessenden as vice-commodore, Schuyler Merritt as rear commodore, C.C. Clark as secretary and H.P. Geib as treasurer. The directors were to include W.M. Smith, J.D. Smith, W.L. Brooks, A.M. Hurlbutt, H.K. McHarg, A.C. Hall, W.W. Skiddy and Albert Swords.

In addition, twelve members were selected for an Executive Committee, and together they would take on the responsibilities of creating the club's constitution and bylaws. They would also be the ones chosen to find just the right location along the Stamford waterfront to build said club.

The property that they were searching for had to be large enough to accommodate a healthy yachting membership and also needed to boast plenty of space to enjoy such leisure activities as swimming, tennis, bowling, skeet shooting, concerts, receptions, dining and cocktailing.

After an efficient yet comprehensive search, a piece of property in the Shippan area of Stamford appeared to be an ideal locale. The club officers chose contractor A.W. Barrett of Bridgeport to do the work, and on April 28, 1891, construction began. The membership, which had already grown to include nearly 125 members and seventeen yachts during the previous few months, enjoyed its first day at the new site on July 25 of that year.

The first official race to be held by the club was scheduled for August 26, 1893. The winner was to receive a beautifully carved silver cup worth $200.

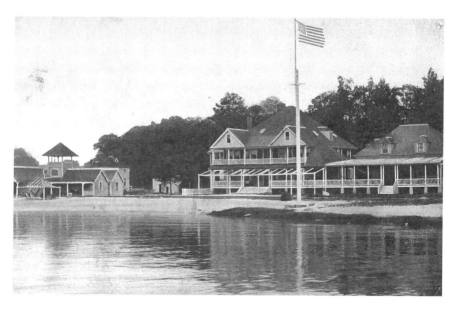

The Stamford Yacht Club, circa 1908. *Courtesy of the Stamford Yacht Club.*

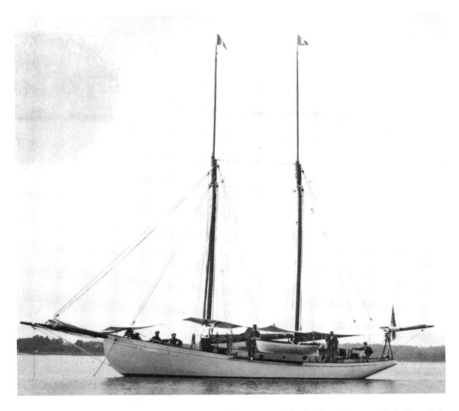

An unknown Stamford Yacht Club vessel cruising around the harbor. *Courtesy of the Stamford Yacht Club.*

The regatta was open to sailboats between thirty-six and forty-three feet in length, and the course consisted of a starting point at the Cow's Buoy off Shippan Point. From there, competitors continued to Matinnecock Point, on to Eaton's Neck and finally back to the Cow's Buoy. The entire journey covered some twenty-five nautical miles along the Connecticut shoreline.

Those entered in the race included the boats *Daffodil* from Stamford, *Alcedo* from Riverside, *Eurybia* from Horseshoe Harbor and *Kathleen* from Stamford. With a light, southwest breeze blowing that day, *Kathleen* proved to be the vessel that would bring the coveted first-place prize home.

Weekly "Saturday Races" made the annual calendar in 1895. That first year saw a healthy fleet of seventeen boats turn out to compete.

By this time, the yacht club was clearly in full swing and was already anticipating many more regattas and events to come. The mooring field was growing at a steady pace, as was an active membership. The various

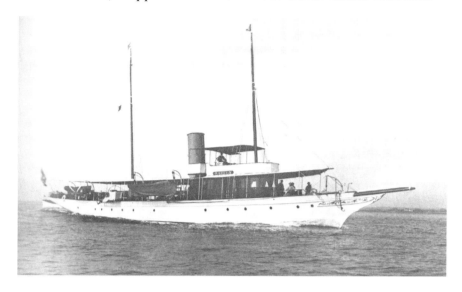

The motor yacht *Christo Bel*, owned by Stamford Yacht Club commodore Walton Ferguson during the early 1890s. *Courtesy of the Stamford Yacht Club.*

types of sailboats claiming the club as their home were reflecting quite an eclectic assortment. Just a few of the vessels represented included classics such as the old Finns, Blue Jays, Rhodes 18s, Flappers, Red Wings, Bugs, Cottontails, Lightnings, Beatles, Victory Classes, Atlantics, Rumpys, Stars, Birds, Buccaneers, Wee Scots and, of course, the Stamford One-Designs.

In addition to the small- to medium-sized sailboats, there would eventually be a great interest in the 5.5-meter class boats during the early to mid-1900s. When these timeless racers were introduced to the scene, the reputation of the Stamford Yacht Club soared to a new level, both locally and internationally.

Many give Commodore Benjamin D. Gilbert the credit for putting the Stamford Yacht Club on the map when it comes to the 5.5-meter class. Gilbert entered his sailboat *Bingo* in the 1964 Tokyo Olympics and was able to secure the bronze medal honors. A second vessel, *Bingo II*, would go on to win the 1967 U.S. Championship.

To give you an idea of the caliber and unique personality of *Bingo* as a competitive sailboat, following is what master skipper John J. (Don) McNamara Jr. once wrote about it: "*Bingo* was a thoroughbred girl, every wave turned her head. A short keel and diminutive rudder were little help. She had a will of her own and saw her own way, dancing or driving a lady to weather, a bitch to leeward, a sailor's delight."

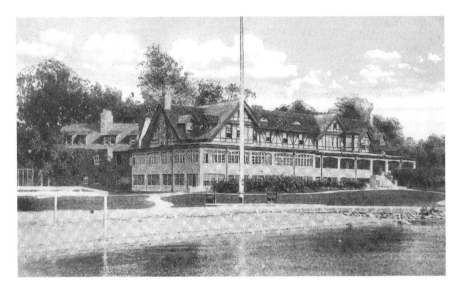

The Stamford Yacht Club, circa 1922. *Courtesy of the Stamford Yacht Club.*

The club, as previously mentioned, was designed to be one of a social character. To help achieve this reputation, the committee members invited some of the top personalities of the time to appear and entertain the membership. For example, Gertrude Ederle, who earned the honor of being the first woman to successfully swim across the English Channel, also owned bragging rights to being the first person to break water in the club swimming pool. On the tennis courts, top professional players like Bill Tilden and Don Budge served their best shots over the net on club grounds. Popular entertainers such as the Happiness Boys and Colonel Stoopnagle had the members laughing and tapping their feet at countless special events held at the clubhouse over the years. There have even been a visit or two by members of the royal family of Denmark, including Her Majesty Queen Margrethe and His Royal Highness the Prince Consort, Prince Henrik. (The prince was actually granted honorary club membership after competing in the annual Friendship Race a time or two.)

With such a diverse cast of characters frequenting the club on a regular basis, it seems quite appropriate that one of its brochures included the following excerpt:

> *No more elegant and complete yachting headquarters exists in the state today, and the institution is unique in this respect, that it has been purposely*

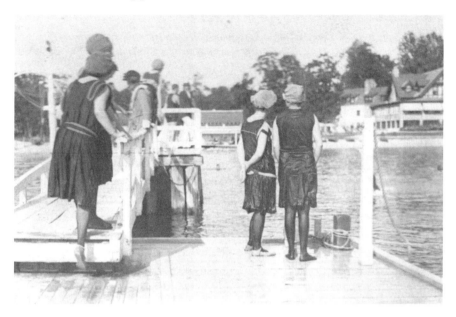

Swimming off the Stamford Yacht Club beach, circa 1916. *Courtesy of the Stamford Yacht Club.*

developed on lines which, while lacking nothing for the convenience and accommodations of the yachtsmen themselves, supply also the attractions of a delightful shore resort for the ladies and children of their families.

As much as fun was indeed the order of the day, it was still important to the members of the club to preserve and uphold a proper image. Part of the effort to achieve this impression was to impose a somewhat formal dress code, which was to be observed at all times as set forth in the bylaws. A sample of just how seriously they took this aspect of club life can be found in the following description of simply the cap that was to be worn as far back as 1911: "Navy blue cloth or white duck, with black lustrous mohair braid band $1\frac{1}{2}$ inches wide; crown for size $7\frac{1}{8}$, cap to be 10" long by $\frac{1}{2}$ inches wide; visor of black patent leather 2" wide and set at an angle of 40-2; chin strap of black patent leather fastened at side with two small buttons."

When it came to the attire for those crewing aboard fleet vessels, following were the guidelines that were to be adhered to:

Shirts of blue flannel or white linen, with wide blue cuffs and collars, stitches with blue or white thread. Trousers of same material as shirt, to be worn without braces. Neckerchief of black silk. Cap of blue cloth with

band, without visor, or straw hats with black ribbon as may be directed. The name of the yacht may be worked on the breast of shirt, or printed upon the cap or ribbon, or both, at the option of the owner. Cap ornaments may be procured by application to the Secretary.

Today, members continue to respect a strict observance to club dress policy.

With an assorted and impressive collection of yachts already filling the harbor, another new and exciting design appeared along the waterfront during the early 1900s. As yet another example of the many masterpieces created by well-known yacht designer John G. Alden, the class of Stamford One-Designs took the sailing scene by storm just after the turn of the century.

One of the more aesthetically appealing of all knockabouts ever built, the Stamford version reflected that of a smooth, balanced and exhilarating ride. A few of the characteristics that made this vessel so unique were that it boasted a somewhat larger freeboard than typically seen on a sailboat during that era, a nicely balanced deck and cabin relationship and a hull form that was both functional and visually attractive.

The Stamford One-Design was no more than twenty-six feet, nine inches in length overall, so it was a perfect size for handling solo or with crew. With a comfortable cockpit layout, sailors could stay out on the water from sunup

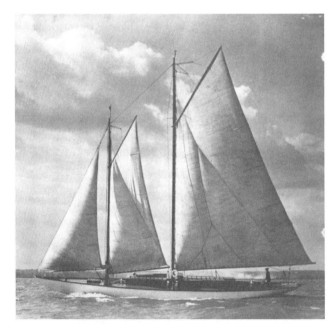

The schooner *Sapho*, one of the Stamford Yacht Club's One-Designs. *Courtesy of the Stamford Yacht Club.*

A Stamford "knockabout," circa 1914. *Courtesy of the Stamford Yacht Club.*

to sundown if they chose to and not feel any worse for the wear once they hit the shore.

The Rice Brothers company of East Boothbay, Maine, built eleven models of the Stamford One-Design. They were all hand-delivered, enjoying their shakedown cruises sailing the coast past Cape Cod to Connecticut. As the humble vessels made their way in oftentimes challenging seas, they proved to be extremely stable and manageable, even with the absence of a self-bailing cockpit. The sail design was that of a gaff sloop rig, with some 342 square feet of sheet to help propel the boat in a variety of wind conditions.

The One-Designs, which were not limited solely to the Alden model, quickly earned their own spot on the race schedule. More than fifty One-Designs of all shapes, sizes and histories could be seen competing during any number of events at the height of the yacht's popularity about 1912. Schooners with imposing sizes of forty-five feet from bow to stern sailed comfortably alongside smaller vessels, usually less than twenty feet long, such as the Red Wings and Bugs.

Speaking of the twenty-foot and under group, the fourteen-foot Red Wing was a well-liked product of the Stamford-based Luders Marine Construction Company. Boasting a V-bottom hull with a ten-foot waterline, a four-foot,

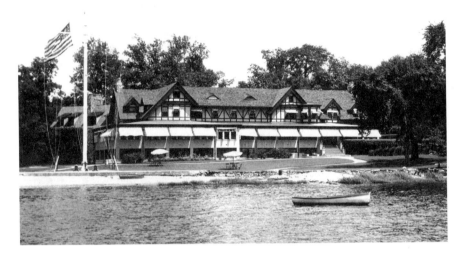

The Stamford Yacht Club, circa 1919. *Courtesy of the Stamford Yacht Club.*

nine-inch beam and a two-foot, six-inch draft, the Red Wings were easily recognized sailing Long Island Sound with their trademark red canvas sails (hence the name).

Interestingly, there had also been another One-Design vessel built that had apparently preceded the more popular Alden design by a couple of years. A naval architecture firm by the name of Cox & Stevens developed the blueprint, and builder Robert Jacob of New York made it a reality. Intended as a cruising sloop, this particular vessel was sixty-two feet in length overall, with an eleven-foot beam and a seven-inch draft. Today, there remains a nicely scaled-to-size replica of the sloop displayed prominently at the club.

Things were going quite well for the young and adventurous yacht club in a relatively short amount of time. However, as often occurs, Lady Luck likes to shake things up a bit every now and then just to keep us on our toes. One of those reality checks occurred on January 14, 1914, when a fire broke out at the club, causing quite a bit of damage. With much work required to return the club to its original state, the 1914 season was questionable. Fortunately, the Riverside Yacht Club in Greenwich came to the rescue and

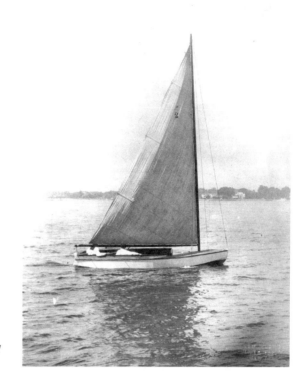

A Stamford Yacht Club sailboat. *Courtesy of the Stamford Yacht Club.*

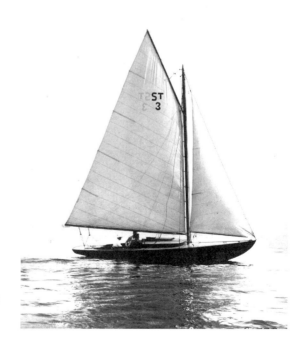

One of the many yachts that moored at the Stamford Yacht Club. *Courtesy of the Stamford Yacht Club.*

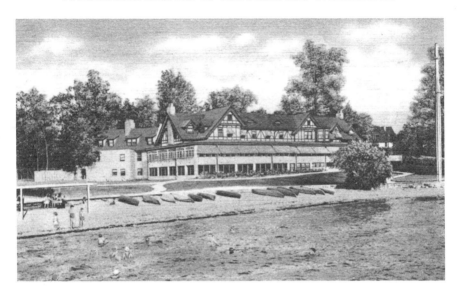

The Stamford Yacht Club, circa 1941. *Courtesy of the Stamford Yacht Club.*

offered the full use of all of its facilities for the entire year to the Stamford Yacht Club membership.

When the club finally reopened on May 21, 1915, there had been a few changes and additions to the original design, including three lawn tennis courts and a large open porch.

As membership was growing and prospering, the list of prominent and successful names being added to the directory became more and more impressive. Successful businessmen and local political figures regularly seen frequenting the club included the likes of Northern Pacific Railroad vice-president James P. Williams; founder and editor of *Yachting* magazine Herbert L. Stone; Vineyard Race initiator George Hubbard; 1935 and 1936 mayor of Stamford and United States congressman Alfred N. Phillips Jr. (also an heir of the Milk-of-Magnesia corporation); president of the New York Stock Exchange and twelve-year America's Cup Committee member James D. Smith; fiberglass hull pioneer Fred Lorenzen; and Pennsylvania Coal Company secretary William E. Street.

The vessels on which these admirable members sailed were just as attention-grabbing as the positions their owners held. A look at just a few of these unforgettable yachts will reveal such names as *Sylph*, a beautifully designed 1880 sailboat. Constructed in Mystic, *Sylph* would go on to have a complete rebuild in 1889. The only part of the original hull that was not

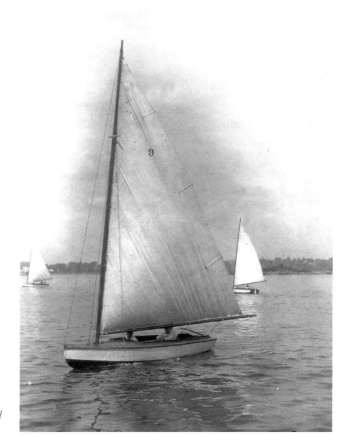

Members of the Stamford Yacht Club enjoying an afternoon sailing on Long Island Sound. *Courtesy of the Stamford Yacht Club.*

changed was the keel. English walnut and California redwood and ash ultimately finished out the rest of this magnificent yacht.

Nirvana was an eighty-foot maxi that was skippered by Commodore Marvin H. Green Jr. *Nirvana*'s claim to fame, aside from its imposing specifications, was its international résumé. Navigating the globe from the Mediterranean to China and everywhere in between, *Nirvana* earned the reputation of being a world-class yacht, sought after by yachting enthusiasts at every port of call along the way.

Another one of the classic boats that made Stamford Harbor its home was the sixty-seven-foot, ten-inch *Pocahontas*. Owned by Commodore James D. Smith, this centerboard sloop was unarguably an eye-catcher on the horizon no matter where it sailed.

A real head-turner was *Doromar*, a 112-foot mega-yacht owned by the McCullough family. The McCulloughs lived in a remarkable mansion just

across the way from the club. Easily larger than any other vessel in the club mooring field at the time, the McCulloughs opted to keep their seafaring beauty in their own backyard.

The fifty-four-foot *Eclipse* was yet another sample of the fine nautical masterpieces that regularly sailed in and out of the Stamford breakwater. Samuel Fessenden was the proud owner of this stunning yacht, and *Eclipse* split its time between the Stamford Yacht Club and the New York Yacht Club.

Cotton Blossom, *Niña*, *Viking*, *Italia*, *Estelle* and *Escort* are just a few of the other colorful and memorable yachts that will forever be etched in the club's history.

Many of the notable captains of these great yachts also proved to be outstanding officers of the club, working their way methodically up the ranks from fleet captain to rear commodore to vice-commodore and, ultimately, to commodore. Familiar surnames such as Lottimer, Smith, Gillespie, Weber, Ziegler, Raymond, Lorenzen, Gilbert, Watts, Rice, McAllister and Lawson are only the tip of a rather extensive commodore iceberg when it comes to the Stamford Yacht Club legacy.

Each and every one of these distinguished commodores has a unique and intriguing story to tell. One such tale is of Commodore Fred Lorenzen. Lorenzen and his family officially joined the ranks of membership in 1944. Lorenzen, his wife and their two daughters quickly became active participants in all things sailing. The commodore began his affection with the sea as a child, and it continued throughout his teenage years and well into adulthood. One of his accomplishments was holding the position of chief bosun's mate in the Stamford Coast Guard Auxiliary during World War II as a young man.

The first event that Lorenzen participated in at the club was with the Rhodes 18 class competitions. Although he enjoyed racing this particular small craft, Lorenzen felt that there were some characteristics of the vessel that could use improvement. The early design of the Rhodes 18, as seaworthy as it was, was also quite prone to leaking due to the many seams and feet of caulking that made up the planked hull. In a search to find a boat that would be more conducive to his sailing style and a bit less maintenance-needy, Lorenzen met up with fellow club sailor A.E. Luders Sr. to discuss the possibilities. Mr. Luders was well known at the time as one of the finest and most talented yacht designers and boat builders in the world. Just as Lorenzen had hoped, Luders had an idea for a molded plywood hull that would remedy the leakage problem. Luders's solid plan gave birth to the

first molded plywood hull of its kind. This new model would find itself in a division all its own, known as the L-16 class. The vessel was twenty-six feet in length overall and boasted sixteen feet at the waterline.

Soon after learning about the L-16, Lorenzen made a purchase and named the boat *Galu*, after his daughters Gale and Lucinda. The enjoyment that Lorenzen exuded while underway persuaded club members Archie Alexander and Benjamin (Bingo) Gilbert to acquire Luders 16s of their own. With three models of this new class of sailboat moored at the club, they innately created a legitimate yacht club fleet. The word about this exciting new racer quickly spread, and soon there were fleets forming at other clubs all over the United States and Bermuda. With plenty of fleets to challenge along Long Island Sound, Lorenzen was never at a loss for finding someone to sail against.

Eventually, Lorenzen's skills at the helm of his L-16 improved to the point of allowing him the confidence to participate in a variety of international events. He chose the International Championship hosted by the Chicago Yacht Club as his inaugural jump into that intimidating scene. Lorenzen selected his wife and two daughters as his official crew, and although they gave it their all, they crossed the finish line in last position. Nonetheless, the experience spurred the adrenaline to continue vying for international honors. The Stamford burgee would fly proudly at a series of other competitions that took the Lorenzens to destinations all over the chart, competing in New Orleans, California, Michigan and Bermuda, to name a few.

As much as the Lorenzens always looked forward to stepping aboard their L-16 whenever the opportunity presented itself, their nautical interests reached beyond just the small boats. Moving on to the completely opposite end of the spectrum, the Lorenzens eventually purchased a Dutch welded-steel vessel named *Seal*. Clearly not of the racing mold, *Seal* did prove to be a rather sturdy cruiser. Confirmation of that arrived when the Lorenzens came out safely on the other side of the devastating effects of Hurricane Carol.

Although the Lorenzens received much pleasure cruising aboard their steel ship for many years, they missed being able to race in the larger fleets. They decided to team up with another reputable yacht designer named Bill Tripp Sr. in the design of a similar vessel to their current *Seal*, but lighter and faster. After many hours of hard work and test models, a forty-foot fiberglass *Seal* was finally splashed in May 1958. The new *Seal* experienced its formal introduction to the racing circuit at the Edlu Trophy Race of that year. To the delight of the entire Lorenzen family, *Seal* number two brought home the coveted first-place trophy at its inaugural competition.

Next on the agenda was to enter the 1958 Bermuda Race. Even though they would ultimately lose the race in corrected time, *Seal* did earn the boasting rights as being the first reinforced fiberglass yacht to ever cross the finish line of the Bermuda event.

During the ensuing years, *Seal* proved its worth as a competent racer. There would be many more cups and awards added to the *Seal* trophy case, including such honors as overall winner in the Storm Trysail Block Island Race, recipient of the 1967 Copenhagen Cup and gold cup holder of the 1961 Monhegan Race in Maine.

Lorenzen became commodore of the club in 1964, and during his tenure in that position he initiated the first of many club cruises and set the precedence for the annual Fleet Parade held at every Commissioning Day event from that point forward.

When his wife, Dorothy, sadly passed away, the Vineyard Committee created the Dotty Lorenzen Trophy in her honor.

The sailing vessel *Seal* cruising on Long Island Sound. *Courtesy of the Stamford Yacht Club.*

Commodore Lorenzen and his steadfast crew of three talented lady sailors have left behind a lasting impression on club members and fellow competitors. Their contributions, both as individuals and as a family, will not soon be forgotten.

Walter H. Wheeler Jr. is another club member who made a name for himself on Long Island Sound. Wheeler performed as commodore in 1933 and 1934 and was one of the youngest to be elected to that position.

The first yacht that he brought to the club was a thirty-five-foot S-boat named *Cotton Blossom*. A second boat, *Cotton Blossom II*, soon followed. *Cotton Blossom II* was a Class B (forty-two- to fifty-six-foot) Q-boat and was part of the seventy-one-yacht fleet at the starting line of the 1934 Vineyard Race. It ultimately won the Vineyard Trophy and Class B honors, finishing six minutes ahead of the leading Class A boat in corrected time.

The *Cotton Blossom* family tree did not stop there. A third sibling came about in 1968 and was a stunning, upgraded version of a twelve-meter design. Shortly after, yet another new arrival would appear in the Wheeler collection. Although this one was originally christened *Hallowe'en* by its former owner, it was quickly renamed to, you guessed it, *Cotton Blossom IV*.

Cotton Blossom IV was a beautiful seventy-one-foot Bermudian cutter built by W. Fife III from Scotland. It came with a pedigree history, having previously won the Fastnet Race in record-breaking time. Although an accomplished racer, Wheeler decided to convert *Cotton Blossom IV* to a cruising yawl.

Niña was another sturdy competitor that actually earned honorary membership in the Stamford Yacht Club as a direct result of an intense and long rivalry with *Cotton Blossom IV*. After many years competing side by side, and alternating wins between corrected times and straight victories, the two vessels, along with their captains, developed a fond admiration and respect for each other's sailing abilities. It was a fun rivalry to watch evolve over the years, and at one point in time, even though *Niña*'s owner, DeCoursey Fales, had earned all rights to the Vineyard Trophy, he ultimately returned them all to the Stamford Yacht Club in a friendly gesture.

DeCoursey Fales was a member and future commodore of the New York Yacht Club when he acquired *Niña*. *Niña* was a leaky, neglected fifty-five-foot staysail-rigged schooner when Fales took over ownership, but through an extensive refit and some tender loving care it became one of the premier racing boats at both Long Island Sound and offshore events. *Niña* accumulated many honors during its long and illustrious career that included the 1941, 1947, 1952, 1953 and 1954 Vineyard Races and the

The yacht *Cotton Blossom IV*, one of the premier racing vessels during the mid-1900s. *Courtesy of the Stamford Yacht Club.*

1962 Bermuda Race, to name a few. Although honorary, DeCoursey will forever be remembered as a true Stamford Yacht Club member.

Two of the younger constituents of the club by the surname of Hubbard appeared on the waterfront scene toward the end of the 1950s and went on to leave their marks on both local and international nautical history. David and Jeremy, the sons of William and Dorothy Hubbard, developed an interest in designing, building and campaigning a series of catamarans that competed in local and long-distance competitions. Both attended the Massachusetts Institute of Technology, and shortly after graduating, the two brothers set forth on their first project, a sixteen-foot single-sail catamaran that, although lacking a traditional cockpit, offered one pivoting board.

Their next design, completed just a year later, was a bit more along the lines of the tried-and-true-style catamarans that boasted full cockpit areas and a sloop rig.

Working with a shoestring budget, the ambitious duo did most of their construction in the basement of their parents' home. It has been noted that the patience and understanding that the elder Hubbards had for their children nearly forced them out of their own home from the intense and constant fumes created by the curing resins.

The sailing vessel *Alacrity II. Courtesy of the Stamford Yacht Club.*

Nonetheless, David and Jeremy persevered. Their second attempt at catamaran construction turned out to be of an impressively efficient design. This was confirmed by its success in a number of regattas, including high-profile events at Sea Cliff, Bayside, Noroton Point and Montreal, Canada.

After watching the 1961 International Catamaran Challenge hosted by the Sea Cliff Yacht Club on Long Island, the Hubbard brothers were hooked on this new and exciting event that eventually became known as the Little America's Cup. With a driving desire to be involved with the internationally recognized regatta, the two men embarked on a game plan to design and build a twenty-five-foot Class C catamaran that would not only compete but hopefully bring home the gold, too.

By early 1963, their efforts came to fruition as they proudly launched their latest masterpiece, *Sealion*. After a successful shakedown cruise, the Hubbards entered *Sealion* in races in Long Island, Massachusetts and Canada. Upon securing the gold at the North American Multihull Championship, *Sealion* went on to earn a spot as the United States challenger for the 1964 Little America's Cup—a dream come true. That year, the highly anticipated competition was held across the pond in England. Although *Sealion* did not fare quite as well as the Hubbards had hoped, it did attract the attention of some of the more prominent designers in the world and put the Stamford Yacht Club on the map of the international catamaran racing circuit.

Over the years, David and Jeremy have been an integral part of a number of impressive hull design projects, including *Alliance*, *Dalliance* and *Patient Lady II*. They not only made a name for themselves, but they also brought the Stamford Yacht Club to an even higher level of prestige.

With all of this talk about the big boat sailing scene, we certainly cannot overlook the accomplishments and success of the junior sailors. One of the most noteworthy events to occur in the history of junior sailing was the introduction of the Junior Yacht Racing Association of Long Island Sound in April 1924. Originated by Stamford Yacht Club members W.F. "Smokey Bill" Gillespie and Jesse A.B. Smith, the advent of this remarkable and innovative concept for junior skippers was an immediate success. From the very beginning, junior competitors from Stamford proved themselves as talented and skilled captains on the waters of Long Island Sound. The 1925 Junior Championship Pequot Cup was won by Stamford Yacht Club junior members Harry W. Sturges Jr., W.B. Wenman Jr. and C.D. Lockwood. The gold medal was also brought home in 1926, this time by the crew of W.F. Gillespie Jr., John D. Fox and W. Wilson Herrick. After several years without a win, 1944 proved to be the comeback year as Robert Thomson, Thomas Hume and Douglas Smith crossed the finish line in first place. That particular trio had a victorious repeat performance in 1946.

The Midget Championship was part of the junior sailing schedule that started in 1926. Also known as the Scovill Cup, Stamford earned its first win in 1929 through the talents of Jessie A.B. Smith Jr., F.G. Wrightson III and Roger L. Offen Jr. That same crew brought home the gold again in 1930, but then the cup left the club property until 1934. That year, the winning Stamford boat was headed up by junior sailors Richard H. Gould, Joseph F. Mayers

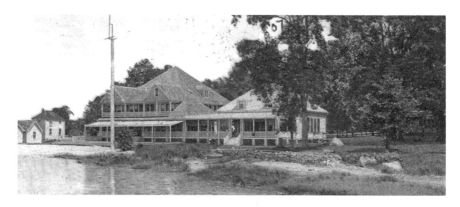

An early postcard of Shippan Point. *Courtesy of the Stamford Yacht Club.*

and M.R. Pitt III. Other victorious years included 1937 and 1945, with John C. Wrightson, John Pitt and Alex Stewart securing the former and William Thomson, Eddie Allen, George Keddy and David Seeley taking the latter.

Toward the mid-1900s, another junior trophy was introduced, this time as part of the Associate Championship class. Created in 1949, the Stamford Yacht Club celebrated its initial A.B. Smith Trophy win in 1952 when the boat skippered by John Zimmerman III crossed the finish line in first position. William M. Thomson enjoyed a Stamford Yacht Club victory in 1953.

One of the most prestigious of all sailboat races in the international yachting community is the Vineyard Race. Originated by Stamford Yacht Club member George Hubbard in 1932, this high-profile regatta has continuously drawn attention from competitors and fans all over the globe during its long history.

At the club board meeting held on July 12, 1932, the following synopsis of the first-ever Vineyard Race was as follows:

Regatta Committee: Mr. J.A.B. Smith reported that there were 23 starters in the Week-End Race to Vineyard Haven and that five finished. Sixteen starters finished the first leg of the race. Mr. Smith also reported that he had received numerous letters of appreciation and that an appropriation of $100 be allowed for prizes and that this be considered an annual event.

The following year, the prize money went up to $200, and it was decided to officially move the start of the race to Labor Day weekend. The annual report of October 10, 1933, included this update:

Our Vineyard Race was eminently successful and promises to be one of the leading Long Island Sound fixtures. We were successful in holding the Manhasset Bay Challenge Cup for another year. The Live Yankee *also brought to the Club two other famous trophies, the Daly and the Childs Cups. I recall no other season where all three of these cups together with Larchmont Race Week, were won by one boat representing one club.*

Each September, the start of the holiday weekend on Friday afternoon reflects a turnout of nearly one hundred yachts anxious to make their way up the coastline. With some 238 nautical miles to cover in just a couple of days, captains and crews know that their skill and expertise will be tested against not only a highly competitive fleet of yachts but the often temperamental personality of Mother Nature, as well.

The designated racecourse begins at Bell Buoy no. 32 off Stamford Harbor, or the Cows, as many cruisers refer to it. Racers then continue on their way to the Buzzard's Bay light tower at Cuttyhunk Island and on to Block Island and beyond, ultimately returning back to, and passing through, the Stamford Breakwater.

In an article written for a 1982 issue of *Yachting* magazine, Editor Bob Baviar wrote the following about the highly touted Vineyard Race:

> *The greatest distance races of the world all have several things in common—a challenging course, competitive fleets and an interesting array of famous yachts.*
>
> *By those standards, the Stamford Yacht Club's Vineyard Race rates close to the top. Like a miniature Fastnet, the Vineyard has a combination of coastal cruising, where currents play a big role, a stretch of ocean sailing, and a mark to round—the Buzzard's Bay Tower—before returning.*
>
> *The Vineyard also possesses an element that is unique in the world of ocean racing. The fleet must pass through difficult, current laden passages in and out of Long Island Sound with names like Gut, and the Race, names that have evoked a quixotic sense of challenge (and dread) to northeastern yachtsmen since the Vineyard Race began in 1932.*
>
> *Since that time, barring World War II, the 238-mile race has faithfully started near the Cows off Stamford, Conn., every Friday afternoon of Labor Day weekend. A parade of personalities—from Arthur Knapp to Ted Turner—have lined up to take a crack at the Vineyard, vexed like everyone else by the diabolical tides.*
>
> *Rudy Schaeffer won the '36 Vineyard aboard his '34 Bermuda Race winner* Edlu. *Harvey Conover won three times in two different* Revonocs—*'37, '45 and '55. I was pleased to be aboard for the latter two wins. Paul Hoffman's* Hother *won in '57 and '58. Bill Luder's* Storm *won in '59 and then again in '61, using a freak rig that confounded the CCA rule. Tom Young's* Shearwater *won in '63 and '65; Dick Nye's perennial* Carina *in 1970 and 1980. Ed Raymond's (the father of current SYC Fleet Captain, Skip Raymond) 32' ketch* Chanteyman *won the race in 1949, the smallest yacht ever to take overall honors. One year,* Chanteyman *spent an entire tide cycle high and dry on (off?) Plum Island and still missed winning her class by a scant minute and 30 seconds.*
>
> *Two grand old gentlemen, Walter Wheeler (a former SYC commodore) in two different* Cotton Blossoms, *and DeCoursey Fales aboard* Niña, *conducted an intense Vineyard rivalry for over 20 years. Having won the*

1928 Transatlantic Race, and the Bermuda Race over three decades later, Niña won overall Vineyard honors no less than five times—'41, '52, '53, '54, and '60—an unparalleled achievement.

The course itself is the real reason why these great men and their yachts return yearly. There are four choices of where to leave and where to re-enter the Sound. The two most popular are the Gut and the Race. But races have also been won by going through Fisher's Island Sound and by skirting the rocks between Gull and Plum islands.

Make the right choice—remembering that the tide changes an hour sooner in the Gut and in Fisher's Island Sound—and it can win the race for you.

These are the terms and conditions under which the Vineyard Race is fought; this is the course that yearly beckons northeastern ocean racing talent. Where else in the world of yachting can you drift backwards through a narrows, swept out of control by the tide, and still hope to win your class?

Paul Hoffman, skipper of the sailing vessel *Hother*, won the Vineyard Race two different years during the 1950s. Hoffman once shared this point of view with a fellow yachtsman about competing in the challenging annual event:

You just have to keep going and come back the next year and see if you can do any better…You have to watch the rocks coming up the Long Island shore in a southerly. There is one rock off Orient Point that we hit three times in three different years. I think it moves around out there waiting for me. If I hit him one more time, maybe he'll roll over and die.

The Vineyard Race continues to flourish in its attendance with its innate and exciting element, as do the many other club races—one of the more notable being the Stamford-Denmark Friendship Race.

As an appealing addition to the already existing citywide Stamford-Denmark Friendship Week itinerary, the race became a formal component of the popular international goodwill extravaganza in 1966. Included in the official program designed for the Friendship week event is the following excerpt:

In 849 King Gorm, the Old, became the first King of Denmark, an occasion which did not perturb the Rippowam Indians in Stamford.

In 1492, Columbus discovered America, an occasion which did not perturb the King of Denmark, because he figured Leif Erikson had previously done the job.

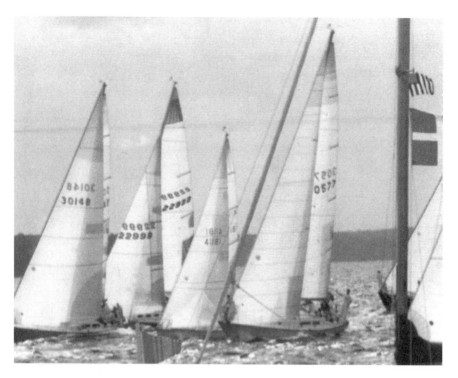

One of the many competitions held during the celebrated Stamford-Denmark Race. *Courtesy of the Stamford Yacht Club.*

In 1641, the history of the town of Stamford started, written by our first town official, Michael Law.

In 1890, the Stamford Chamber of Commerce was founded. At that time the Vikings had long since lost their original world market on account of their abominable trading habits, which included decapitating reluctant customers. A more friendly breed of Vikings evolved, the ones we face today with new ideas on peace and war and balance of trade.

When the high seas competition first joined the program, the Stamford Power Squadron, which was led at that time by Commander Sey Colen, and the Stamford Yacht Club's Race Committee made sure that they put on an unforgettable affair. The steel-hulled vessel *Sheba*, owned by club member Benjamin D. Gilbert, was appointed as the committee boat that would oversee the initial field of twenty-two competitors.

The first trophy to be awarded was presented aboard entertainer Victor Borge's yacht and was won by Arnold Forester and his boat *Prime Evil*. The

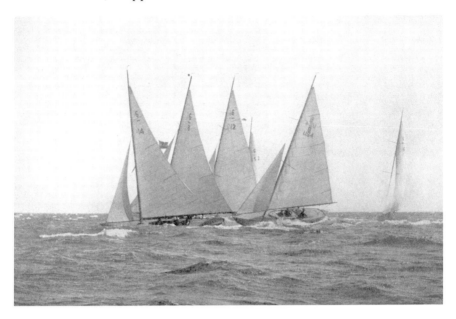

Competing for the SYCE Elimination Trials during the early 1900s. *Courtesy of the Stamford Yacht Club.*

Copenhagen Cup was the only "formal" prize, as all other awards were recognized with a case of Danish beer.

In the ensuing years, the event experienced some fine-tuning and tweaking to the original curriculum, replacing the beer awards with such honorable trophies as the Denmark Cup, the Royal Danish Yacht Club Trophy, the Little Mermaid Cup, the Tuborg Skoal Bowl, the SAS Royal Viking Cup, the Royal Copenhagen Trophy, the Queen of Denmark Cup, the Aalborg Akvavit Trophy, the His Royal Highness Prince Henrik of Denmark Trophy, the Crown Trophy, the Friendship Cup, the Stamford Power Squadron Trophy, the Kings Memorial Trophy, the Novo Mug, the Coco Cup and the Roger Sharp Trophy.

Clearly, both the Stamford and the Denmark components of this popular and fun sailing event enjoy giving and receiving trophies.

What began as a simple concept to shorten the long ride home at the end of a day cruising on Long Island Sound has turned into a historic, memorable and distinctive maritime journey that continues to attract passionate and discerning yachting enthusiasts. Today, the Stamford Yacht Club remains one of the most prestigious and respected clubs on the eastern seaboard, drawing hundreds of competent and recognized skippers every year as they try their hand at any number of coveted trophies, cups and awards.

Hathaway, Reiser & Raymond

Sailmakers Extraordinaire

For any sailboat owner worth his salt, it is an understood fact that the collaborative result of design, construction and function of their sails is by far the most important ingredient to an enjoyable and productive sailing career. Along coastal New England, the demand for quality sailmaking is high.

You see, those who live on the Atlantic shoreline take their sailing seriously. As well they should, since the maritime history of the area rivals no other in the world.

It was discovered many centuries ago that if a seafarer were to take a flattened-out piece of animal skin or some type of woven mat and attach it to a couple of tree limbs, secure it to his boat and wait for some level of wind gust, the paddles could be set to the side while the power of that wind propelled the vessel across the water. What an amazing realization that must have been!

Today, some two hundred years later, the art of sailmaking has made many giant steps forward. The improvements in sail types and materials alone are enough to send your imagination reeling.

The first sailmaker must have made quite an impression on the ships' captains and crews of his day with his single-sail design. Today, they would probably be rendered speechless by the selection available to the yachtsman. Mainsails, genoas, jibs, spinnakers, staysails, drifters, reachers and storm sails are regulars on any sail loft menu of this century. It is difficult for a

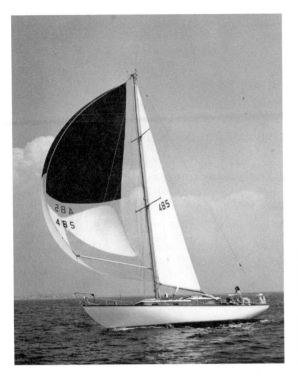

Left: One of the custom-designed sails of Hathaway, Reiser & Raymond. *Courtesy of Hathaway, Reiser & Raymond.*

Below: An example of the fine sail designs of Hathaway, Reiser & Raymond. *Courtesy of Hathaway, Reiser & Raymond.*

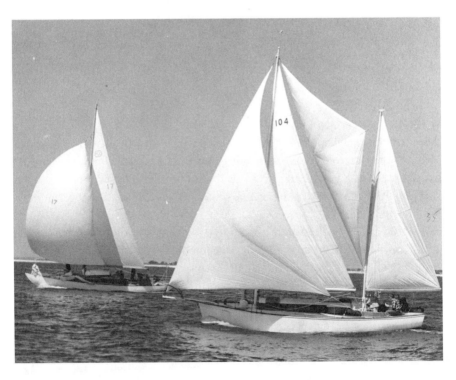

nonsailor to comprehend the need for such a wide range of sails, but if one were to look at all of the different hull designs and sailing agendas, it would become clearer.

From swift racing sailboats to long-range cruisers, from ten-foot prams to eighty-foot schooners and from lightweights to heavy hulls, the variables necessary to create movement can get pretty complicated.

One of these key variables is sail weight. During the early 1880s, it was not uncommon for the collective weight of, say, a seven-masted schooner to weigh in at the incredible figure of eighteen tons. And that was if it were dry. Nowadays, those numbers are easily 30 percent lower. With the changes in cloth material and the continuing advancements in the field of sailmaking, it is only feasible that these improvements are going to get better.

One of the most influential developments in the production process is the method of construction. During the early years, it would require acres of

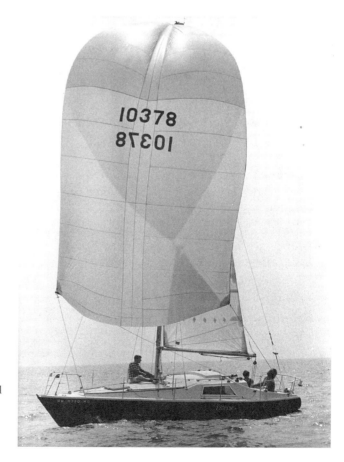

One of the unique sail designs of Hathaway, Reiser & Raymond. *Courtesy of Hathaway, Reiser & Raymond.*

A few of the original tools of the trade found at the sail loft and rigging department at Hathaway, Reiser & Raymond. *Courtesy of Hathaway, Reiser & Raymond.*

canvas, long and laborious hours of hand stitching and painstaking precision in cutting skills to produce even one sail. In today's market, time may still be an issue, but on a much different level.

Computer programs and high-tech software have been developed over the last few decades that are capable of dealing with any number of calculation changes. They also allow for more flexibility and offer options in regards to sail panel design. Laser cutters have replaced hand scissors for cutting and shaping, sail sections are now glued together rather than sewn and personal input as far as color and character all contribute to the unique ambiance of any given yacht.

Worldwide, sailing continues to be an ever-changing sport. Although the technologies and faces may also change, the traditions of craftsmanship and pride in a sailmaker's work remain constant. Along the Connecticut coastline, these characteristics are exceptionally strong. Following in the steps of the early craftsmen, Stamford has the honor of being home to one of the oldest and most reputable sailmakers in maritime history.

The company of Hathaway, Reiser & Raymond has been in operation since 1890 and has maintained a successful business at its shop on Selleck Street since the early 1950s.

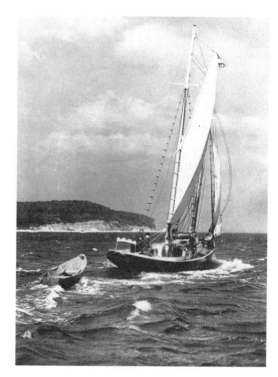

Right: One of the many sailboats seen cruising regularly around Stamford Harbor. *Courtesy of Hathaway, Reiser & Raymond.*

Below: The Hathaway, Reiser & Raymond sail loft on Selleck Street. *Courtesy of Hathaway, Reiser & Raymond.*

When you walk into this humble brick building located on the border of Stamford and Old Greenwich, you can actually "feel" the history of sailing. As the second-oldest continuously running sail loft in the United States, it is no wonder why.

Alden Reiser, an avid yachtsman and skilled sailor who hung his first sailmaking shingle in Nova Scotia, came to Boston, Massachusetts, in 1890 to try his hand in America's boating market. Once there, he befriended an employee of the Herreshoff sail loft in Bristol, Rhode Island, by the name of Asa Hathaway. At the time, Hathaway was in charge of sailmaking at the prestigious and established firm.

With common interests, it was not long before the two men realized that they had a similar approach to the sailmaking business. Reiser proposed that Hathaway partner with him in his new venture in Massachusetts. After careful consideration, Hathaway accepted the offer.

Reiser and Hathaway's new business did quite well for many years at their Boston location. The two entrepreneurs, however, eventually decided to

Alden M. Reiser of Hathaway, Reiser & Raymond enjoying a sail on Long Island Sound. *Courtesy of Hathaway, Reiser & Raymond.*

Edgar "Ed" Raymond, one of the original partners at Hathaway, Reiser & Raymond. *Courtesy of Hathaway, Reiser & Raymond.*

move their operation to Connecticut as they saw great potential to expand their clientele list a little farther south.

After signing the lease for a store in Cos Cob, it was time to look for some additional staff to help with their ever-growing workload. One of the men who stood out was Edgar Raymond, a young man raised in a decidedly sailing family. Raymond also boasted a rather notable résumé of his own. After brief deliberation, it was decided that Raymond would become the third expert partner in an already talented company during the late 1940s.

At that point in time, things were really beginning to take off for the busy sail loft. The Connecticut site was commissioned to design and produce sails for some pretty impressive yachts during the early to mid-1900s. America's Cup defenders *Vigilant*, *Defender*, *Columbia*, *Reliance* and *Resolute* are just some examples of the caliber of sailboats that came to be fitted out at Hathaway, Reiser & Raymond. Each and every time, the local loft delivered.

Looking for a better space in which to work, the company found what it felt to be the ideal locale in 1958. That year, the three owners saw a sheriff's auction advertisement in the local paper:

> *The Bankrupt Estate of Anthony M. Burriesci—Known as Village Restaurant—Corner Selleck & Durant Streets—Stamford, Connecticut.*

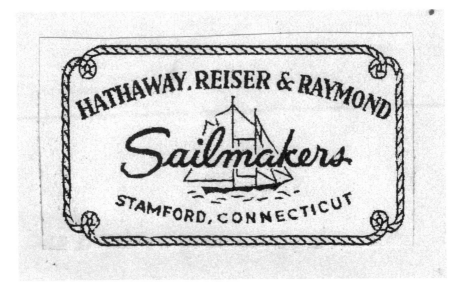

The Hathaway, Reiser & Raymond sail loft logo. *Courtesy of Hathaway, Reiser & Raymond.*

Attractive Modern 2-story Brick and Masonry Commercial Building, 4610.75 sq. ft. on the first floor and 3526.55 sq. ft. on the second floor. First floor was used as Dining Room and Bar and is attractively decorated with some wood paneling and acoustic ceilings. The floors have Ken-tile. The building has a good heating system, ample rooms on both floors and in general in excellent condition, constructed primarily as an eating place. The detailed layout in the Kitchen is well done.

Building is located on Lots No. 57, 58, 59 and 60—Southwest Corner of Selleck and Durant Streets, Stamford, Connecticut and was constructed in 1956.

This property is located in close proximity to an entrance and exit to the New England Thruway.

All Public Utilities are available. Zoned for Light Manufacturing.

Stamford is a highly desirable industrial location because of favorable local tax rates, local power rates and "No State Income Tax." Capable co-operative workers—both men and women—skilled, semi-skilled and unskilled are available in ample supply. Stamford, about 46 minutes from Grand Central Station, via frequent express trains, is a congenial, cultured place of residence for executives and their families.

Contents of Restaurant—9 Aluminum Leather Plastic Stools, Chairs, Draperies, Tables, Vanity Tables and Benches, Cash Register, Fire

The storefront at Hathaway, Reiser & Raymond. *Courtesy of Hathaway, Reiser & Raymond.*

Extinguisher, Aluminum Refrigerator (Sta-Kold), Miscellaneous Kitchen Appliances, Utensils, Kitchenware, Etc., Frigidaire Freezer, Gas Pizza Oven, Exhaust Fan, Step Ladders, 22 Cases of Soda, Folding Chairs, Saw Horses, Ice Soda Coolers, Coat Hangers, Compressor, Tile Boards, Electric Ceiling Fixtures, Floor Tiling, Highball Glasses, Etc., Silverware, Guest Checkbooks, Chinaware and Pottery, Tablecloths, Dishes, Liqueurs, Unfinished Lavatory material, Etc.

Upon signing on the dotted line, the joke around the shop was that the former owners either chose a bad location or they didn't serve very good food. Whatever the reason that the building was ultimately put up for sale, it turned out to be in the favor of the sailmakers.

Hathaway, Reiser & Raymond now had a strong foothold in the yachting industry. Their reputation of being one of the best sail lofts in regards to design, production, expertise and customer service went far beyond domestic borders. Although the majority of their customer base was stateside, the company also serviced an international community that included customers from Europe, Japan and South America.

As already mentioned, the firm had a history of supplying yachts competing for the America's Cup honors. Add to that celebrated list contenders in several

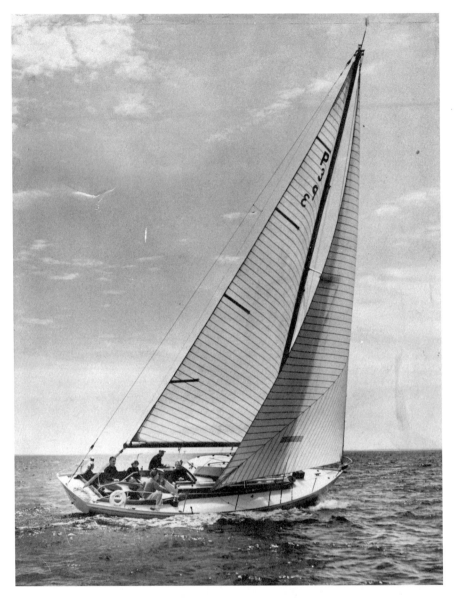

The yacht *Nimrod III* sailing out of Stamford Harbor. *Courtesy of Hathaway, Reiser & Raymond.*

Trans-Atlantic Races, Bermuda Races, the Fastnet Races in England, the Mackinaw Races on the Great Lakes, the Buenos Aires–Rio de Janeiro Races in South America, the Halifax Race and the Southern Ocean Racing Conference and its story becomes even more extraordinary.

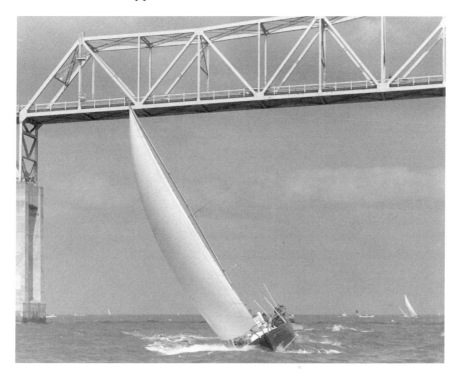

The sailing vessel *Rhubarb* competing in Tampa Bay, Florida, with sails made by Hathaway, Reiser & Raymond. *Courtesy of Hathaway, Reiser & Raymond.*

When Wilbur L. Scranton Jr., president of the Chatfield Paper Company in New Haven at the time, needed some sails for his twenty-four-foot boat *Trina*, he knew just where to go. After equipping his vessel with sheets and rigging directly from Hathaway, Reiser & Raymond, *Trina* went on to secure the first-place trophy in nine consecutive distance races in midget ocean racing and off soundings competitions.

Many of the company's customers experienced similar success stories, as is shared in the following letter dated January 20, 1960, and addressed to the company from a satisfied client:

Gentlemen:

I think that you will be very pleased to know that my yacht "PANDA PRIMO" (IInd class R.O.R.C.) using your sails has been very successful in the "GIRAGLIA" Race of 243 miles (Toulon–Giraglia Island in Corsica, San Remo), the most important and long mediterranean yachting race.

Among the 40 racing yachts from France, Italy and Spain (15 of the Ist class, 13 of the IInd class and 11 of the IIIrd class), PANDA PRIMO has arrived IV E.T. and I C.T. (general class) and I E.T. and C.T. (its own class).

Owing to the fact that PANDA PRIMO uses your sails, I think that you will be pleased in knowing its brilliant performance.

Many cordial greetings and thanks also from my crew.

The list of competitive yachts that have been outfitted with sails and rigging from Hathaway, Reiser & Raymond is long and impressive. A few other notable vessels include *Carina*, a fifty-six-foot long-distance cruiser that won two Trans-Atlantic Races; *Katama*, the Class D winner of the 1960 Bermuda Race; *Figaro*, winner of the King of Sweden Cup in the 1960 Trans-Atlantic Race from Bermuda to Marstand, Sweden; and *Chanteyman*, a vessel that accumulated more than fifty class prizes during its illustrious career.

In addition to the competitive class of sailboat, the company designed sails and rigging for countless numbers of local, middle-distance and

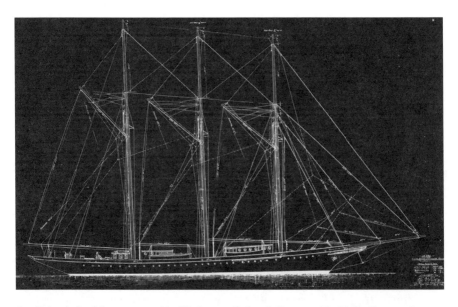

A sail sketch for *Migrant*, created by Hathaway, Reiser & Raymond in 1928. *Courtesy of Hathaway, Reiser & Raymond.*

circumnavigating cruisers, not to mention the United States Coast Guard's 230-foot, square-rigged training vessel *Eagle*.

One of the reasons that Hathaway, Reiser & Raymond has done so well for so long is that its staff has always been a sailing group by nature, beginning with Alden Reiser. Through its many years in operation, extremely talented and knowledgeable yachtsmen, experienced in all types of sailing situations, have consistently been employed at the loft.

One of the most talented of all was Edgar Raymond. As a young boy, Raymond had the opportunity to go out on the water regularly with his father, who earned his living in the oyster farming trade. As a matter of fact, the oyster farming business went as far back as Raymond's great-grandfather. Raymond's father had also been honored with several decorations from the American, French and Italian governments for his outstanding service and small boat seamanship skills during both World War I and World War II. His task in the military was to safely transport fleets of vessels from the United States to Europe.

Growing up in a nautical family, it made sense that when the younger Raymond came around he, too, would search for his niche along the water. After mastering his junior sailing skills, Raymond went on to test his abilities against the larger boats. One of the most memorable aspects of Raymond's career was when he paired up with his wife, Fay, and entered the 1936 National Dinghy Association event. The couple won the title that year and proceeded to secure the gold in the annual regatta for many years after. They also took the lead in a variety of other two-crew events for nearly a quarter of a century, including earning the first Triple Crown in the history of the Larchmont Yacht Club with victories in the fall, winter and spring Frostbiting Series.

When it came to Raymond's solo career, he excelled at his craft. Competing in his thirty-three-foot ketch named *Chanteyman*, his name was often found in the win column no matter where he was sailing. In twenty-five years of participation in the Vineyard Race, *Chanteyman* brought home six class titles and one overall title. When he was not busy carrying the gold out of the awards tent, Raymond was collecting honors in the second-, third- and fourth-place positions.

The Stratford Shoals Regattas proved to be another favorite of Raymond's—he tallied up seven first-place wins in that event. And when it came to the annual Huntington Yacht Club Overnight affair, Raymond apparently crossed the finish line in the lead so many times that it has been said that "the club would need a silver mine to provide him the trophies to which he is entitled."

A winter storage cover designed by Hathaway, Reiser & Raymond. *Courtesy of Hathaway, Reiser & Raymond.*

The Norwalk Yacht Club Wednesday Night Series, the Off Soundings Yacht Club Regattas and a variety of other local competitions more often than not saw the bow of *Chanteyman* at the finish long before any other vessels were in sight.

Raymond tested his skills in waters other than Long Island Sound, as well. One of his most memorable experiences was when he performed as co-helmsman aboard the *Weatherly* during the 1958 America's Cup Trials. When asked in retrospect what he thought about his unique opportunity, Raymond was quoted in the *Hour* as saying:

I never worked as hard in my life as I did the four months aboard that boat. I was on it every day without letup.

*We won eight of the first 11 trial races against the other three boats (*Columbia, Easterner *and* Vim*). Then we lost two of three in a series we didn't realize was sudden death. We were really burned up about it and were ready to pack and leave Newport. But after a while I began to think about it and I prevailed upon the crew to stay two weeks.*

An interesting story about Raymond and *Weatherly* is that when the America's Cup defender was initially to be launched from the Luders Shipyard in Stamford, there was, apparently, a potentially serious glitch. As the very expensive yacht was about to be splashed, it began turning to port when it was supposed to be heading toward starboard. With the keen eye and quick thinking of helmsman Raymond, who had a front-row seat as to what was happening, a sure disaster was able to be avoided. Raymond observed that the quadrants had inadvertently been hooked up backward.

Since the error was caught in time, thousands of dollars worth of damage was able to be averted. There is no doubt that Raymond received a good amount of praise for that one.

A few years after the America's Cup stint aboard *Weatherly*, Raymond joined the crew of *Figaro* in its attempt for the Admiral's Cup. *Figaro* was owned by Westport resident William Snaith at the time.

The five-race series was a grueling one, boasting four short courses before embarking on the fifth and final 650-mile trek. The ultimate challenge took competitors from the Island of Cowes located in the English Channel to Fastnet Reef along the southern tip of Ireland and then to Plymouth just off the southeastern coast of England.

Although the weather was less than accommodating (actually, there was a storm brewing that rivaled the best that Mother Nature can stir up), *Figaro* and its captain and crew would prove their steadfastness and finish in first place.

Raymond's wife, who had been waiting anxiously for any news about the safety of her husband in Dublin, was relieved when she finally saw a photo of him in a local paper: "I was very worried by the weather until I saw a picture of Ed one morning on the front page of the Dublin newspaper. He was at the helm and it was obvious he was drinking a Coke. He took quite a bit of razzing about that afterward."

The stress of the race was softened upon the Raymonds' return home when they were able to sit back and enjoy putting together an album of their trip, which included photos of the couple at the awards dinner and dance with Queen Elizabeth and Prince Philip.

Other tributes to Raymond's brilliant sailing career include winning the 1935 National Class A honors; the 1937–40 National Dyer D gold; the 1947 and 1948 National B-1 Design competition; the 1947 Nassau Race; the 1948, 1952 and 1958 Bermuda Race Class B title; four Southern Ocean Racing Circuit first places in five years (1959 to 1963); and the 1965 Trans-Atlantic Race that took competitors from Bermuda to Scandinavia.

When not sailing or competing, Raymond was assuming his responsibilities on land as commodore to four different yacht clubs. The Norwalk Yacht Club, the Storm Trysail Yacht Club, the Off Soundings Yacht Club in Mystic and the Frostbite Club all were entertained by Raymond's colorful storytelling and candid anecdotes about the life of a sailor.

Raymond ultimately stood as the sole remaining partner in Hathaway, Reiser & Raymond by the early 1970s. At that point in time, there was another of the Raymond generation who, like his father, grandfather and

great-grandfather before him, had sailing in his blood. F.P. "Skip" Raymond, Edgar's son, took over as president of Hathaway, Reiser & Raymond in the mid-1970s after learning about the business under his father's tutelage. The senior Raymond often tested his son by throwing a production challenge at him. For example, the younger Raymond was once presented with the proposition of designing a better-performing model for a spinnaker. Skip not only accepted the task but did, indeed, present his father with an improved version of the sail.

It was tests like that one that would ultimately help to make the new president a proficient problem-solver. When Frank V. Snyder, vice-commodore of the New York Yacht Club at the time, was looking for someone to design a particular style of sea anchor for his 1984 voyage from New York to Antigua, he knew right where to turn. Sea anchors are intended to hold a vessel strong to the water as they are cruising in heavy seas in order to try and stabilize the yacht, as opposed to traditional anchors that secure a boat to the sea floor while remaining stationary. After months of searching for a sea anchor with a proven record and that could be easily stored, Snyder was coming up empty-handed. When Raymond was presented with the challenge, he immediately set to work on an equation that would hopefully solve his client's dilemma.

When Snyder initially approached Raymond, it was suggested that perhaps he could create a design for a sea anchor made out of some type of netting, as opposed to the traditional method of using canvas. Obviously, the netting would have to be durable enough to be able to carry upward of twenty-five tons or so, as most oceangoing vessels in the fifty- to sixty-foot range tend to weigh in around that number. It would also need to be resilient enough to withstand hurricane-force winds, as you never know what Mother Nature might throw at you while on the open ocean.

After taking these factors into consideration, Raymond believed that an extra-strong nylon webbing—stitched together by one of the firm's specially designed machines that cater to products such as safety harnesses—just might be the way to go.

Another aspect to bear in mind was that the open end of the new anchor needed to be larger than the ones made out of canvas. This meant that three to four feet of steel rod would ideally be required to fit it properly. Unarguably, that is quite a bit of steel rod, and it would be clearly difficult to get such an object down the companionway or through the hatch, especially during bad weather conditions. Donning the thinking cap once again, Raymond offered the use of wire as a viable option. By using wire, the anchor would not only

be able to be stored more efficiently, but it would also be pliable enough to simply pop right open once released from its storage bag, thus saving time in preparing it for service.

With all of the pieces of the puzzle presumably in place, Raymond began creating a test model of the anchor. His idea to utilize nylon webbing and wire as the materials worked out quite well, as it allowed a sailor to easily put the full-size (three feet by four feet by one foot) anchor snugly into a bag the size of only two feet by one foot by four inches. Quite an impressive amount of space saving!

Snyder gladly accepted the finished anchor, thanked Raymond for his clever approach and hard work, added his new acquisition to the existing gear on *Southerly* and prepared to set sail for ports farther south.

Snyder and his crew departed New York Harbor on November 17, 1984. The first thirty hours of their voyage were fairly uneventful, with wind and seas making for a reasonably smooth passage. As they approached the Gulf Stream, however, the onboard barometer suddenly took an unexpected, and rather substantial, drop.

As night began to fall, the breeze picked up to around Force 10, and thunderstorms began to appear around them. As things progressed, the seas began to churn, and the captain and his crew soon found themselves caught up in one of the swiftest-moving currents they had ever experienced. Realizing that it was time to pull out the big guns, the crew set out the vessel's storm trysail.

Southerly, by all rights, is a sturdy vessel at forty-three feet in length overall, with a hefty fourteen-foot, six-inch beam. Designed by Sparkman & Stephens and built by Paul Luke, it typically handles rough weather without much effort. Except for this time.

During that fateful day, *Southerly*'s steadfast constitution was no match for the tumultuous sea and weather conditions as it struggled to hold its own against the storm. Knowing that they were now in a dire situation, Snyder ordered the crew to dispatch the new sea anchor. It was finally time to put Raymond's ingenuity to the test.

For more than three hours, the sea anchor fought with the raging sea. As Snyder and his crew watched anxiously to see just who would win, they were more than pleased when the home team came out victorious. The sea anchor designed by Raymond and built by the staff at Hathaway, Reiser & Raymond was a success!

At the first opportunity, Snyder called Raymond to let him know how his creation had performed. Obviously, the sail loft president was quite pleased to hear the news.

Hathaway, Reiser & Raymond shop foreman Dominick DeNardo during the early 1950s. *Courtesy of Hathaway, Reiser & Raymond.*

An added appeal to the sea anchor, as Raymond pointed out, is that it could also double as a man-overboard recovery basket. Quite a versatile piece of equipment to have on board, one must agree.

For more than a century, Hathaway, Reiser & Raymond has catered to an elite clientele that demands perfection when it comes to sails and rigging. Time and time again, the firm has delivered, often far above all expectations. Today, the company is headed up by two former employees, Tom Anderson and John Savage. Together, they continue to maintain the company's reputation of excellent service and outstanding production. The original founders believed in going the extra nautical mile for their customers, and it is no different today, as the company continues to be one of the most sought-after sailmakers in the international yachting community.

The Luders Legacy

When it comes to maritime legends, there is none who is quite as remarkable as famous boat builder and designer Alfred E. "Bill" Luders Jr.

Luders's father, A.E. Luders Sr., was actually the one who got the ball rolling for his son, but junior would ultimately take it and run with it just about as far as he could go. Interestingly, both father and son earned their educations from the Webb Institute of Naval Architecture.

Luders Sr. founded the Luders Marine Construction Company in 1908 and at that time set up shop along the Byram River in East Port Chester, New York. Eventually, Luders moved his operation to a permanent yard in 1912 on the property of what is now known as Brewers Yacht Haven at the foot of Washington Boulevard in Stamford. He did so with only $1,000 to bankroll the new venture. The company catered to a vast clientele, designing and building numerous types of vessels of all shapes, sizes and purposes.

Luders Sr. was one of the first designers and builders to work with marine gasoline engines. One of his designs was published in 1906. That particular model was a twelve-horsepower, two-cylinder engine and was part of an open launch design vessel.

Recognized as a yard that could pretty much build anything that you asked it to, it was no wonder that when World War I and World War II

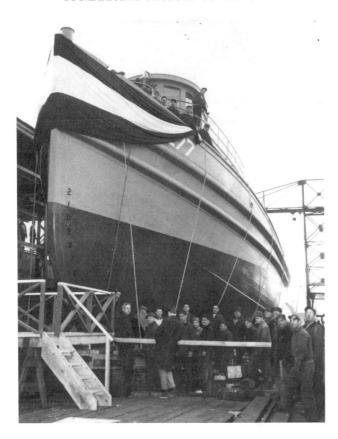

One of the Luders shipyard's government-commissioned vessels. *Courtesy of Brewers Yacht Haven.*

broke out, the United States government sought the expertise of the Luders Marine Construction Company to build its defense vessels.

During that tumultuous time in history, Luders constructed and delivered more than one hundred vessels that were ready for service in the United States effort. Since the Luders yard had specialized in building ships made of wood, it had very little experience working with steel at the time. Nonetheless, Luders and his talented crew appeared to have made the transition quite easily.

Included in the government inventory were minesweepers, patrol craft, harbor tugs, tow-target boats, barges and submarine chasers that were utilized by the U.S. Navy for military operations overseas. The work kept the Stamford shipyard busy for quite a few years. Luders vessels were also used during the Korean War.

An interesting project that the yard took on during that time was to begin construction on molded plywood life rafts. The intention of these

life rafts was that they were to be deployed from airplanes to assist pilots and crew that had gone down at sea. As a forerunner in the technology of this new concept, Luders worked on improving the formula by incorporating wood veneers and utilizing hefty autoclaves to help the glue to cure strongly and efficiently.

Luders's wartime vessels were so well built, in fact, that his naval patrol craft design won a contest sponsored by Franklin D. Roosevelt during World War I. This led to a commissioning for the yard to build ten more patrol boats for use by the Coast Guard in 1924. These seventy-five-foot vessels were utilized in following bootleggers and smugglers who were attempting to conduct their business deals along our local shorelines.

At the height of the wartime production schedule, Luders employed some 1,200 workers to help him complete the jobs. This was a tremendous increase from the original 25 whom he had hired when he first opened up his doors.

While Luders Sr. was creating a successful business, his son was not far behind in following in his shoes. However, as a young man, Luders Jr. much preferred playing on the water than working on it. With a keen affection for sailing and racing in his early days, by the time Luders Jr. was sixteen years old he had already made a name for himself in the local racing circuit. Entering his six-meter *Hawk* in the 1926 championship regatta, Luders came out victorious. Five years later, Luders not only took home the gold in that same competition, this time at the helm of a boat named *Totem*, but also secured seventeen more first-place finishes throughout the entire racing season that year.

As a young skipper without much money in his pocket, Luders Jr. was very appreciative when he would receive a break every now and then in the expense column. One such financial "gift" came about when an accomplished sailor from Greens Farms named Briggs Cunningham offered the young captain his old mainsails and jibs. There was no hesitation on Luders's part as he gladly accepted the sheets and then went on to sail them to a number of victories.

Although the six-meter and the Red Wing classes were two of Luders Jr.'s favorite boats to sail, he was also proficient at handling the larger vessels, such as the ten-meters. This talent was made clear when he led Albert Johnson's *Nachvak* to a third-place overall season standing in its respective division. That honor was a direct result of having brought home eight first-place finishes during the year.

As much fun as the young Luders was having on the high seas, his father reminded him that all work and no play was only going to last so long.

Taking him under his wing, father began teaching son the ins and outs of the boat building and design business. With a natural talent just like his father, Luders was able to quickly understand the integral workings of the maritime industry.

When Luders Sr. sadly passed away, he left behind a flourishing business that was continuing to grow bigger and better. Fortunately, he left it in good hands with his number-one employee, his son "Bill."

With the war comfortably over, the next Luders generation was able to focus primarily on building pleasure and racing vessels.

Among the first types of sailboats that Luders got involved with was one of the company's own designs known as the Luders 16. When the Fishers Island Yacht Club was searching for a new junior-class racer during the early 1930s, it approached the Luders shipyard. With the idea to find something for the junior sailors to race in that would be different than the typical "chunky"-shaped small boat models that they were used to, Luders suggested his latest L-16 design ("L" for Luders and "16" to reflect the length at the waterline) that followed the blueprint of the International Rule Sloop of that day—in other words, one that would be similar to the larger six-meter style.

Luders recycled the shipyard's molded plywood idea from when it was building warships in the construction of the L-16s. When the process was applied to the junior sailboats, they were referred to as "hot molded."

The finished model boasted five $1/8$-inch thick mahogany veneers and topped out at 26 feet, 4 inches in length overall. Its beam was 5 feet, 9 inches and its draft was 4 feet. At 16 feet, 4 inches along the waterline, the L-16 had a displacement weight of 3,200 pounds. The sails included a main, genoa, jib and spinnaker. The approximate sail areas were 158 square feet, 108 square feet, 61 square feet and 298 square feet, respectively. A small but comfortable cuddy cabin allowed for the possibility of two berth accommodations for overnight excursions.

The Fishers Island Yacht Club took receipt of fifteen L-16s for the 1934 season, and they were raced extensively for nearly four years with huge success. Unfortunately, when the great hurricane of 1938, also known as "the Long Island Express," barreled through the New England coastline, nearly every vessel in the fleet was lost. Those that did make it through the damaging storm were scattered all along the shoreline. However, there had been enough exposure for this new class of sailboats prior to the storm that it had acquired quite a large fan club in a relatively short amount of time.

One of the people who took a liking to the most recent Luders creation was a man named Clare Udell from Chicago. Udell and six of his fellow

racing colleagues commissioned seven L-16s to be constructed for their Windy City fleet that year, and in 1948, their fleet took first-place honors in the Ocean–Great Lakes Challenge Cup.

At the time, Luders was charging $1,950 per boat for his innovative racers, which made them quite accessible to all levels of sailors. And, indeed, the L-16s found homes everywhere, from the blue-collar backyard to the Rockefeller mansions.

As the Chicago fleet grew in popularity, neighboring cities and states wanted to get in on the action. Louisiana, California, Maine, New York, Connecticut and even Bermuda were next in line to join the ranks of official L-16 racing fleets that competed in a variety of class regattas.

All over the country, existing classes were beginning to switch to the L-16 boat, such as when the Gehrmann Trophy utilized the new vessel in 1947. The Mallory Cup and the Adams Cup were two additional competitions that eventually became L-16 regulars. When competing in open regattas against other classes of boats, the L-16 proved to be a winner, crossing the finish line well ahead of the larger-class boats in a number of contests.

Luders's prototype was a hit well into the 1960s among yacht clubs and junior programs all around the United States, as well as internationally. On average, as many as twenty L-16s could be seen at a time on any given waterway, testing their skills against other similar models. When the introduction of fiberglass hulls came on to the scene, Luders continued to build the L-16s for a while, but his preference was always the wooden construction version.

There have been many compliments awarded the L-16, both verbally and written. One such example of flattery was included in an article from the March 1945 issue of the *Rudder* that stated:

> *The method of staying the mast of the new L16, with its absence of running backstays, makes for ease of handling, while the tall, modern sail plan, with plenty of opportunity for setting kites, will make its appeal to the keen racing man. The outboard profile of this yacht is particularly pleasing by reason of its clean lines and balance.*

An additional excerpt stated that "[f]or racing, or course, the boat is ideal, being perfectly balanced, fast and weatherly and, in addition, beautiful to look at."

One of Luders's most famous projects was the twelve-meter sloop *Weatherly*. Designed by Philip Rhodes, *Weatherly* was constructed by the

Stamford shipyard in 1958. The vessel turned out to be Rhodes's only twelve-meter endeavor.

The *Weatherly* was built with the intention of campaigning in the America's Cup competition as a viable contender for the highly prestigious award.

Once *Weatherly* was completed and successfully splashed, it immediately earned the reputation of being a swift and graceful yacht, with great potential to bring the America's Cup home. As one description of the impressive yacht put it, "She is stunning to see under sail, with the long overhangs and finely tapered ends of a classic. She is beautifully appointed below decks; she glistens with raised mahogany paneling, tuffed leather seating and the warm glow of varnished wood."

Built to the highest construction standards in the industry, *Weatherly* boasted the best of African mahogany, white oak and durable bronze.

During its first entry at the America's Cup trials held in Newport, Rhode Island, in 1958, *Weatherly* experienced a late start and was ultimately eliminated. It was then back to the shop, where Luders decided to make a few integral modifications before its 1962 attempt.

Weatherly would, however, eventually hold the gold when it finished in first place in the 1962 contest skippered by the legendary Emil "Bus" Mosbacher. *Weatherly* defeated a very upset crew on board the favored Australian challenger *Gretel*. *Weatherly* also claimed fame to being the first America's Cup victor that had accomplished the feat as an "old" boat.

Apparently, President and Mrs. Kennedy were huge fans of the Luders-built *Weatherly* and kept a close watch on all of the developments during that exciting 1962 event.

Weatherly continued to try its hand at the prestigious international event until 1970, at which point it was converted to an offshore racer to be sailed on the Great Lakes and Puget Sound. Today, *Weatherly* remains in operation primarily as a charter boat. It has the honor of being one of only three surviving wooden America's Cup defenders in the world. It has earned the title of being "a true legend in American sailing history" and is known worldwide as having one of the finest pedigrees in all of yachting.

Following in the wake of the *Weatherly* was yet another America's Cup twelve-meter yacht, named *American Eagle*. This particular contender was both designed and built by Luders in 1964. The same year that the vessel was splashed, it was entered to compete in the 1964 observation trials in Newport, Rhode Island.

American Eagle performed brilliantly during the fierce competitions, winning the trials hands down. However, by the end of the racing season, a

rival yacht named *Constellation* was selected as the America's Cup defender from the United States.

By then, there was someone new who had expressed keen interest in acquiring the magnificent and fast *American Eagle*. Ted Turner signed on the dotted line in 1969 and went on to sail his new boat to many victories through 1976. Included on his list of accomplishments with *American Eagle* are earning the gold in the first World Ocean Racing Championship; record-setting wins in the illustrious SORC, the Fastnet Race and the Sydney Hobart Race; and being the recipient of the distinguished "Yachtsman of the Year" award. Other voyages included the Bermuda Ocean Race and a variety of races on the European circuit.

After being sold by Turner in 1976, *American Eagle* spent most of its retirement years cruising the oceans of the world as a charter yacht. Its reputation as one of the last recognized wooden yachts to be built still stands today.

When the commuter yachts came onto the scene during the years leading up to the Great Depression, Luders's was one of four reputable yards in the area that vied for local contracts. Consolidated, at Morris Heights in the Bronx; Purdy's, out in Port Washington, Long Island; and Henry B. Nevins at City Island were the other area builders that produced these luxurious and fast commuter boats that regularly transported the "big wigs" on Wall Street to and from their suburban estates. The design of the boat reflected an overall length of anywhere from thirty-five feet to fifty feet, a relatively narrow beam and unique low cabin tops.

To help his yachts stand out from his competitors, Luders historically placed his signature gold scroll high at the bow of the boats. When it came to commuter yachts, Luders was considered "the Tiffany of yacht builders."

Another one of Luders's masterpieces was the Clipper Series, which he designed for the Cheoy Lee company. This particular style of sailboat was offered in thirty-three-foot, thirty-six-foot, forty-two-foot and forty-eight-foot models. They were described as being of a "mostly ketch-rigged" design (in other words, cutter ketches equipped with a Yankee, staysail, mizzen and main), but the thirty-six-footer could also be commissioned as a straight cutter rig. The three larger versions had the options to be built as staysail schooners, as well. Pilothouses were only included on the forty-two-footer.

The Clipper yacht was a rather heavy vessel, boasting a displacement-to-length ratio of 464 for the thirty-six-foot model and 389 on the forty-two-footer.

The Clipper 36 was introduced to the sailing scene in 1969 and continued production until about 1988. The Clipper 42 came into the picture about

1970, and the thirty-three- and forty-eight-foot models were mixed in during that same time period.

Luders was also the design genius behind the Cheoy Lee 30, the Offshore 28 and 47 and the Midshipman 36 and 40.

The junior Luders added to his allure by developing the 5.5-meter competitive class sailboat. For many years, the 5.5 meter ruled local and international waters, appearing at the Olympic games and in regattas sponsored by prominent clubs such as the New York Yacht Club. The 5.5 meters were one of the last series of racing yachts that Luders constructed before closing the yard.

Considered the final cruising design project that Luders worked on during his illustrious career is the Sea Sprite 34. The thirty-four-foot model of this popular series is the largest in the Sea Sprite fleet. Although designed by Luders, the boat was built by the C.E. Ryder Company in Bristol, Rhode Island. The vessel is known for its classic lines and its full keel. It is made to take following seas quite well and can take on ten-foot swells with the best of them.

The Sea Sprite 34 can easily and comfortably sleep six crew members. The last hull in this series was completed in 1986 and was named *Halcyon*. Today, *Halcyon* can still be seen sailing the waters of the Elizabeth Islands and Westport River in Massachusetts.

The list of vessels that have been designed and built by Luders over nearly a century is extensive. Other yachts of note in his amazingly impressive inventory include the showboat *U an I*, the commuter yacht *Bambalina III*, the motor yacht *Zapala* (which President Calvin Coolidge was frequently photographed aboard), the ketch *Bonnie Dundee*, the motor yacht *Sea Dream*, the motor yacht *Arroyo*, the motor yacht *Kathmar*, the motor yacht *Spindrift*, the motor yacht *Hippocampus*, the six-meter yacht *Challenge*, the motor yacht *Catamount*, the motor launch *Piquant*, the motor yacht *Gilnockie*, the motor yacht *Ginger-Dot*, the diesel tug USS *Penacook*, the yawl *Escapade* and the sailing yacht *Dove II* (the boat that sixteen-year-old Robin Lee Graham sailed while completing his circumnavigation).

Luders's clientele list was just as long and intriguing as his vessels, delivering to yachtsmen the likes of King Olaf of Norway, actor Yul Brenner, Nelson Rockefeller and the famous Pulitzer family.

With such an outstanding résumé, it was devastating to the Luders family when a fire broke out at the Stamford shipyard in 1962, virtually destroying nearly all of the business records, photographs and contract files. Even today, the search continues for anyone who might have any

A.E. "Bill" Luders (left) with prominent West Coast yacht designer and boat builder Bill Lapworth, known best for his Cal 40 yachts, during a rare meeting on the deck at the Stamford Yacht Club in 1995. *Courtesy of F.P. "Skip" Raymond.*

information or old images of the yachts built and designed by the company over the years.

When the introduction of fiberglass hulls and molds came about, it seemed that the newer generations of sailors could not get enough of them. Even though he was not thrilled with the idea, Luders did attempt to work with this new type of construction material. In an interview with the *New York Times* when he was in his eighties, Luders was quoted as saying: "We dabbled in fiberglass and made a few prototype boats, but we didn't want to get into it. It seemed to us that if you built with fiberglass you did not need to be on the water."

Luders finally decided to close the famous boatyard in 1968, bringing an end to an amazing era in nautical history. Although his working career was over, his passion for sailing was as strong as ever. Luders was often seen sailing with his wife, Peg, in their small boat as they journeyed over to Long Island for dinner, a tradition they began years earlier when Luders said, "It was good for business." Even into his late eighties, Luders could be seen daily taking his personally designed twenty-one-foot sloop *Sprig* out of its slip at Yacht Haven West (the site of his former shipyard) for a cruise around Long

Island Sound. Bill always did prefer small boat sailing to the larger boats. When once asked if he ever considered participating in ocean or distance racing, Luders said, "I like to sleep in a bed, preferably ashore."

A.E. "Bill" Luders passed away at his home in 1999 at the age of ninety.

The Luders Marine Construction Company had an excellent run in the yacht design and boat building industry for nearly seventy years that rivaled no other in the maritime industry. Initially under A.E. Luders Sr.'s watchful and insightful eye, then with father and son working side by side and finally headed up by Bill Jr. as a solo owner, the name Luders will forever be etched in the pages of yachting history.

The Natural Charm
of the Halloween Yacht Club

The Halloween Yacht Club is a charming and unassuming seaside establishment located adjacent to Cummings Beach, just next door to the entrance to Shippan Point. Its origin dates back to 1926 when a group of yachtsmen and sailors sought to create a boating "organization" of sorts.

The Halloween Yacht Club initially found a spot at the end of the harbor channel closest to where the water meets the mainland. Without the assistance of breakwaters to retain the drifting of soil and sand into the channel, it became apparent early on that a dredging project would be necessary in order to preserve the integrity of the channel.

After careful deliberation of the logistics of such an undertaking, it was decided to clear out enough of the slowly narrowing waterway so that a small harbor would be formed. This, in turn, would allow for the passing of vessels in and out of the lagoon with more ease.

Once the final plans were drawn up, the inclusion of two breakwaters in front of the Cummings Park bathing pavilions seemed to make sense. During the dredging process, an old boathouse was set up as a temporary home for the recently created Halloween Yacht Club.

Once the new channel and expanded lagoon were successfully dredged, a new public beach area also arose. It was given the name of West Beach, as it still stands today. The improved lagoon area proved itself not only as an

accommodating additional cruising opportunity for small boats but also as a safe haven for vessels during stormy weather.

It was at this point in time that the "temporary" clubhouse was offered by the City of Stamford as an official home for the Halloween Yacht Club. The members accepted the offer to acquire the building, knowing full well that a lot of work would have to go into making the run-down structure presentable. Most of the windows were broken, the doors were off their hinges and frames, the interior lockers were destroyed, the floors and walls were seriously damaged, the heat had not been working for years and there was a great amount of debris covering the floors everywhere one looked.

Nonetheless, the members of the Halloween Yacht Club saw through the obvious state of disrepair and had a vision of their own for bringing the worn-out seaside structure back to life. Joining forces, they all set to work on their clean-up and refurbishing project. Members utilized their best talents as they rolled up their sleeves and scrubbed, buffed and polished everything in sight. Doors, windows, floors and walls were either repaired or replaced. The plumbing was brought up to speed, and the heat was fixed. An offer by the City of Stamford to paint the exterior of the boathouse was gladly accepted by the members.

Once the new clubhouse was finished, the next task on the to-do list was to construct docking and mooring facilities. The members came up with an appealing purchase price for prospective slips that worked for both the club and its boat owners. With a reasonable and attractive plan on the table, it was not long before boaters were placing their orders.

As with any new organization, the first few years are always the trial-and-error period. For the Halloween Yacht Club, that stage lasted for about five years, and by the beginning of 1931, they finally found themselves fairly grounded.

As the membership grew and more boat traffic was finding its way to the humble-sized "Halloween Harbor," it was agreed upon that some type of channel markings for night navigation would be wise. The club made an official request to the City of Stamford on August 1, 1929, to erect one green light and one lantern on either side of the channel entering the lagoon. In addition, three buoy markers—two of which would be lighted—were suggested to help distinguish the natural jig-jag design of the lower section of the channel. All of the requests were granted, with the stipulation that the club would be responsible for monitoring the lights. That plan worked out just fine for nearly a decade, at which point in time the United States Coast Guard agreed to initiate its own aids to navigation on May 11, 1937.

Although the clubhouse and mooring facilities were now in place, it would prove to be an ongoing work in progress to continually update, expand and improve the club amenities. Local businesses and private donors would periodically supply lumber, hardware and elbow grease to help build new floats, docks and ramps. Some of these generous supporters included Mr. Gandy, Mr. Norloff and Mr. Winter, who gifted an impressive and sizeable ship's wheel lighting fixture for the clubhouse; Mr. Shavoir, who presented a saluting cannon with close to eight hundred shells; Mr. Rodies, who gave his time and materials for painting projects; Mr. Carlton E. Smith, who supplied his electrical skills in rewiring anything that the club needed; Mr. Norloff, who kindly gave a variety of lighting fixtures appropriately resembling the white lights of seafaring ships; Dr. R.R. Gandy, who donated a gas water heater; Commodore Winthrop A. Clarke, who offered the use of his houseboat, named *Coffee Boat*, as a "café"; Mr. Vaughn, who gave a gas heater, copper boiler, pipes and fittings for the shower room; Mr. Frank West, who donated a fireplace set; Mr. Heller, who gave a tile pipe connector for the septic tank; and Miss Helen Smith, who donated $400 toward the cost of piling and dock repairs. There are many other generous gifts that were received from a variety of people that came in the forms of money, equipment, materials, time and labor that, together, all helped the club to become an impressive and functioning part of the Stamford yachting scene.

With the clubhouse now in shipshape condition, it was time to create a formal constitution, bylaws and mission statement. It was determined that the goal of the newly formed Halloween Yacht Club would be "to encourage and foster the sport of yachting, the art of yacht designing and building, the science of seamanship and navigation, and to further the social interest of its members."

When the time came to design a burgee that would appropriately represent the club and its unique name, the members turned to the collaborative talents of Mrs. Alfred N. Phillips Jr. and Mr. A.E. Luders. Their final drawing depicted a flying witch riding on a broomstick against an orange and black backdrop.

A few years into the club's existence, there came about the realization that in order to keep the club maintained to an acceptable level for both members and the City of Stamford, the hiring of a full-time steward would be necessary. Since the idea was to have a constant watch on the property seven days a week and twenty-four hours a day, an upstairs living area was constructed toward the end of the 1930s so that a steward and his family could reside there comfortably.

The steward's responsibilities were to include cleaning, heating, painting and performing any repair work necessary to maintain the condition of the docks and floats so that they were secure and safe; to look after the club's boat fleet and accompanying equipment for members when they were away; to be ready and willing to assist members and guests with their lines or supplies if needed; and to keep the club grounds and adjoining beach areas clear of debris and trash.

The introduction of a steward at the club came about the same time that the proposal of a new remodeling project was brought to the table. Once again, members came forward offering their assistance. Some of the more notable donations for the undertaking included an oil burner and air conditioning unit from Mr. Gerli; painting services by Mr. Rodies; labor for removing the rear wall partition by Mr. Barney; electrical work by Mr. H.F. Smith; and plumbing fixtures, pipes and fitting from Mr. H. Heller. When the work was finally completed on February 9, 1938, the club had new floors, a chimney, a working fireplace, new light fixtures, air conditioning, additional rooms, a fresh coat of paint all the way around, double-doors leading outdoors, a coat room, a telephone, a kitchen area with a gas stove, a new bathroom, new showers, new porch walkways and a larger, roomier deck area.

Along with all of the much-needed additions came some appealing decorating that truly helped the club feel like home. A large ship's wheel lighting fixture now hung from the ceiling in the middle of the main room, and the white lights traditionally found on ships were strung around the tops of the walls. The yacht club burgee and signature emblem were proudly displayed in a featured spot where everyone could appreciate them.

An interesting visitor appeared at the Halloween Yacht Club docks on July 7, 1937. Looking for a place to rest for the evening during the final leg of a four-year around-the-world voyage, the thirty-nine-foot Norwegian pilot boat *Ho-Ho* requested permission to stay in the local lagoon. The club was more than happy to grant the celebrated vessel's request, and members were repaid with a wonderfully intriguing account of the boat's journey given by crew members Mr. B.V. Bryhn and Mr. T. Thorstein Schyberg. The excursion, which had been sponsored by the Royal Norwegian Sailing Club of Oslo, Norway, offered a unique diversion to the typical everyday activities usually experienced by local club members during the summer season.

Less than a year later, the Halloween Yacht Club received a letter dated April 4, 1938. It had been sent by the Royal Norwegian Yacht Club and was signed by the Crown Prince of Norway as commodore, expressing sincere gratitude for the exceptional hospitality shown to the captain and crew members of the *Ho-Ho* during their overnight stay.

It was officially agreed upon to form the club's first-ever Ladies' Auxiliary during a club meeting held on February 14, 1938. Mrs. Fischer was voted in as president, and Mrs. McGourty accepted the position of vice-president. The tasks of the Ladies' Auxiliary were to function purely as a ladies' social group, as well as to help out with other club committees when needed, oversee the care of the club with other members, to be in charge of the interior decorating and furnishing and to coordinate the preparation and serving of club meals.

The first Bingo Party was set up by the Ladies' Auxiliary on April 28, 1938, and brought in $150.50, which went toward the cost of decorating.

Over the years, the challenge of keeping the narrow channel and lagoon that lead to the Halloween Yacht Club navigable and safe has been an ongoing project. One of the more drastic dredging motions came on May 14, 1940, when the club, along with the nearby Muzzio Brothers Shipyard, joined forces and hired the Packard Dredging Company out of Boston, Massachusetts, to blast away a large rock that stood where the channel makes a sharp turn. In addition, the dredging company was asked to remove an inner and outer sandbar area, thus allowing the dimensions of the channel to extend to fifty feet wide and six feet deep. The entire project took about two weeks.

Over the years, the members of the Halloween Yacht Club have made maintaining the clubhouse, surrounding property and docks and mooring spaces a priority. The membership continues to be appreciative to the City of Stamford for the original opportunity to make a home for their club at the end of the channel that runs along Cummings Park. Since its inception, they have also strived to create a successful and productive relationship with the local United States Coast Guard Auxiliary and the local United States Power Squadron, offering the use of their clubhouse as a formal center of operations.

Today, the club continues to provide a humble nautical environment for all types of boaters. Many of its members have been cruising the waters of Long Island Sound their entire lives and have wonderful and entertaining stories to share about their experiences. The ambiance remains laidback and casual, yet there is an air of formality on the appropriate occasions. The Halloween Yacht Club has seen many changes since its founding nearly a century ago, and it plans on hanging around to see plenty more.

The Breakwater
Irregulars Set Sail

The Breakwater Irregulars is, unarguably, a unique name, and it certainly catches your attention.

It all began when Stamford yachtsman and accomplished sailor Dick Sockol was looking for a different type of boating challenge during the mid-1960s. Sockol had already pretty much competed and sailed in every possible race and regatta that he could get his hands on, and he enjoyed participating in every one of them, yet he had a yearning for something new and different that could stir things up a bit.

After some deliberation on the subject, Sockol thought that he had an idea that just might work, so one evening in 1967 he invited a few of his closest cruising buddies to listen to his plan.

Sockol told his attentive audience that he wanted to establish a distinct and individual theme for a yacht club, one that he envisioned as strictly for family racing, "cruiser style." After taking a moment to think it over, his fellow sailors were all in agreement that it sounded like a good idea, and they were happy to back him up. Now that it was official, all they needed was to come up with a name.

Sockol opened up the membership to anyone who had a sailboat—of any size, any make and any model—as long as it could realistically be considered a family cruising yacht.

The club ran without any official clubhouse to speak of, and the only formal officer was the founding commodore. In other words, Sockol would be the one and only person in charge. Membership dues were minimal, and any and all club policies were decided on by Sockol pretty much on the run.

Club meetings were either held on the water prior to the start of a race or after the last boat crossed the finish line, while grabbing a pizza and some beers from a local watering hole.

Sockol's plan was virtually flawless—informal, casual, fun yet competitive at the same time, cost-efficient, no overhead to worry about and not one other person to argue with (or blame) regarding club politics other than himself.

That initial season attracted quite an eclectic collection of vessels that included a Cal 20, a Bounty 41, a Columbia 24, a Pearson 35, a Morgan 27, a Greenwich 24, an Alden 38 and a Santana 25.

Because of the extraordinary nature of the members' boat specifications, the new club, understandably, soon earned the reputation of being a bit of an "irregular" organization.

During that inaugural year, most of the competing sailors berthed their vessels in Stamford Harbor, so for convenience purposes, Sockol designated the two breakwalls located at the entrance to the harbor as the start and finish lines for all of the club races. By cleverly combining their "breakwater" start and finish line with their "irregular" fleet, Sockol and the other club members finally had a name.

Since the premise was to have all of the boats competing in the same division, Sockol saw the need to create a handicap system that would base the final results on each individual yacht's respective design, potential speed and the captain's level of—or lack of—racing experience. Throughout the season, Sockol would reevaluate the numbers to make sure the system continued to work smoothly.

About twelve boats competed in the first season of the Breakwater Irregulars race series. Just four years later in 1971, the fleet nearly doubled in size. Today, there are countless sailboats at any given competition throughout the year. Still low-key, still casual, still relatively inexpensive and still a whole lot of fun, the Breakwater Irregulars Yacht Club is operating as strong as ever.

Chapter 11

Notable Yachts

There have been numerous yachts of note that have visited the Stamford Harbor throughout the years. From small skiffs to medium-sized working boats to magnificent schooners, the list is exceptional as well as extraordinary.

One of the vessels that stands out is the seventy-one-foot, eleven-inch *Pocahontas* that was owned by Stamford Yacht Club commodore James D. Smith. The boat was designed and built by David Kirby from Rye, New York, in 1881 and was a center-board sloop boasting sixty-seven feet, ten inches at the waterline; a generous beam of twenty-one feet, six inches; an eight-foot draft; and a net gross tonnage of 46.78. The mast stood at an imposing seventy-four feet; the top mast at six feet; the boom at six feet, six inches; the gaff at forty-two feet; and the bowsprit at forty-four feet.

When initially drawing up the blueprint, Kirby's intention was to create a vessel that would offer all of the comforts of home yet be sturdy and seaworthy enough to withstand a variety of offshore cruising conditions. Kirby was quite successful in every detail and successfully delivered one of the most eye-catching yachts ever to sail the waters of coastal New England.

Another maritime masterpiece regularly seen sailing on the local horizon during the late 1880s was an eighty-five-foot, six-inch centerboard schooner originally built in 1880. After a major refit was completed in 1890, however, the original design was nearly entirely changed. The name of the yacht was *Sylph*, and it was the product of talented boat builder J.M. Bayles & Company

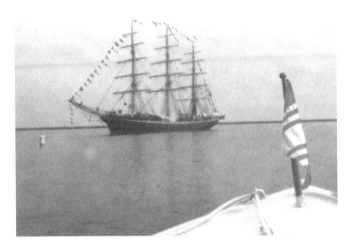

The Danish
training vessel
Georg Stade in
Stamford Harbor.
*Courtesy of the
Stamford Yacht Club.*

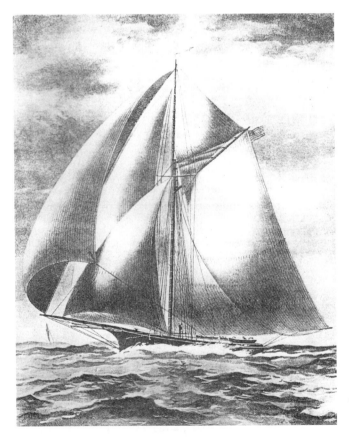

The sailing vessel
Pocahontas, owned
by Stamford Yacht
Club commodore
James D. Smith.
*Courtesy of the
Stamford Yacht Club.*

from Port Jefferson, Long Island. Other dimensions of this classic seafaring beauty included a waterline length of seventy-two feet, nine inches; a beam of twenty-two feet; a draft of seven feet, two inches; and an overall weight of 68.32 gross tons.

F.M. Wilson, also from Port Jefferson, supplied all of the vessel's sails. The interior woodwork reflected a perfect combination of bird's-eye maple, California redwood, English walnut and ash. Many considered *Sylph* to be "one of the best built and best equipped vessels in every way in the American yachting navy."

Avid yachtsman Samuel Fessenden commissioned yacht designer and boat builder C.A. Willis from Port Washington, New York, in 1881 to create a sloop for his personal use. After listening to Fessenden's wish list, Willis came up with just the right answer. Based out of the Stamford Yacht Club, *Eclipse* was a beautifully appointed fifty-four-foot sailboat with a seventeen-foot beam; four-foot, six-inch draft; forty-nine-foot waterline length; and 25.26 gross tonnage. It was the perfect size and design for Fessenden, and he sailed his custom yacht at every opportunity.

Steam launch boats were quite popular during the late 1800s. One of the most admired along the Stamford shoreline was the thirty-foot *Advocate*. Built in Boston in 1886, *Advocate* was owned by *Stamford Advocate* newspaper publishers the Gillespies. With a humble beam of six feet, the *Advocate* could

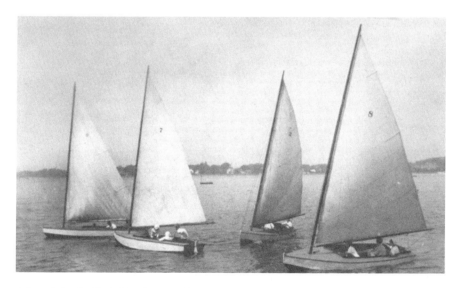

A few of the Stafford Class boats sailing on Long Island Sound during the 1920s. *Courtesy of the Stamford Yacht Club.*

comfortably carry up to a dozen passengers with its six-horsepower Shipman engine and was often seen cruising the harbor.

An interesting vessel that clearly stands in a class by itself is the former whaling boat *A.T. Gifford*. When it came to whaling along the Connecticut coastline, the primary fishing grounds were farther north in New London, Stonington, Norwich, Mystic, Groton and East Haddam. As you headed south toward New Haven and Bridgeport, the fleets, although still active, were much smaller. When it came to Stamford, the city claimed just one official whaling vessel, the *A.T. Gifford*.

Owned by New York City furrier F.N. Monjo from about 1907 to 1914, the *A.T. Gifford* had gone through a series of other owners since its initial launch in March 1883. At eighty-two feet, six inches in length overall, the yacht was originally designed in Essex, Massachusetts, as a schooner. By the time Monjo utilized it as a whaling vessel, the local whaling industry was beginning its slow demise. Interestingly, even though Stamford had only one whaling vessel to its name, that sole ship provided the city with the credit for producing the last whaling activity in the state.

The yachts of yesteryear were as varied and unique as their owners. The cumulative stories alone could easily fill a book of their own.

Chapter 12

The Waterfront Today

The Stamford waterfront has clearly experienced many changes over the years. From cornfields and gristmills to wartime operations and navy shipyards to yacht clubs and mansions, the shoreline has been able to adjust nicely to a variety of new situations.

Today, Stamford Harbor is still host to an eclectic group of seafaring vessels that grace the entrance daily. Sailboats, power boats, mega yachts, charter vessels, work boats and personal watercraft that range greatly in size, shape, make and model innately catch the attention of shore-side fans enjoying an afternoon at the water's edge.

The Stamford Yacht Club remains a landmark destination for discerning yachtsmen from around the area, hosting a full schedule of races and regattas all season long, as does the Halloween Yacht Club located at the end of the channel adjacent to Cummings Park.

Brewers Yacht Haven West Marina currently sits on the historic property where the famous Luders Marine Construction Company once operated. Next door to Yacht Haven West, a small, yet longstanding, casual club named the Ponus Yacht Club entertains tired skippers and crews at the end of the day, as it has for generations.

Brewers Yacht Haven East, located at the beginning of Shippan Point, is another nautical hub of action, with a handful of smaller marinas and luxurious waterside condominiums dotting the coastline along the way.

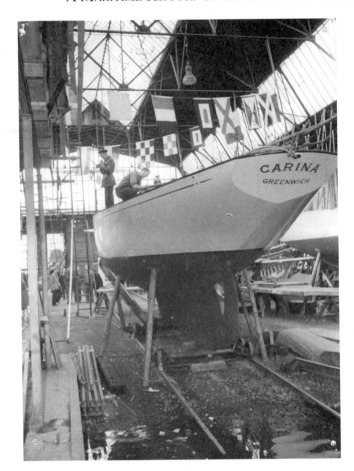

The sailing vessel *Carina*, two-time winner of both the Trans-Atlantic Race and the Fastnet Race and Class B winner of the 1956 Bermuda Race. *Courtesy of Hathaway, Reiser & Raymond.*

The members of the Young Mariners Foundation have found a home base at Southfield Park, from which they set sail each summer teaching inner city kids the ins and outs of sailing, self-confidence and teamwork.

Shippan Point maintains its reputation as being one of the wealthiest neighborhoods in all of Connecticut. Immaculate homes and beautifully landscaped lawns reflect a bygone era when great steamships delivered thousands of excited vacationers a year to its pristine parks and scenic shorefront.

On the other side of the Shippan Point peninsula, closest to the Darien border, Cove Island Park continues to attract countless visitors annually to its picturesque and expansive piece of land along beautiful Long Island Sound. The Soundwaters sailing and educational program now makes its home beside Holly Pond in the historic Holly House as it teaches young sailors about boating and the marine environment. Remnants of the old

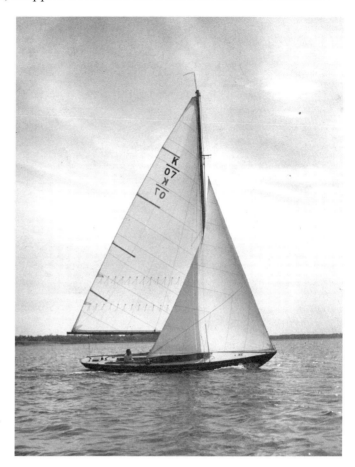

The 1907
Herreshoff
sloop *Kittiwake*
on Long Island
Sound. *Courtesy of
Hathaway, Reiser
& Raymond.*

mills can still be found scattered all around the park, if you simply take the time to look.

Canal Street remains an active and busy industrial section of the city, with outstanding dining and shopping opportunities all throughout the area.

The innate beauty and ideal location of the Stamford waterfront are just two of the reasons why people have been drawn to the area for centuries. As the city continues to grow and evolve, the shoreline also proves to adjust to the times.

For those who live here, as well as for those who come to visit, the impressive and unique history of the Stamford waterfront can still be felt. The local maritime legacy of a bygone era will always remain an important part of a very special time in New England history.

Bibliography

America's Cup Charters. www.americascupcharters.com.

"A.T. Gifford (ship)." http://en.wikipedia.org/wiki/A._T._Gifford_%28ship%29.

Breakwater Irregulars. http://breakwaters.org.

Connecticut History Online. http://www.cthistoryonline.org/cdm-cho/index.html.

"Cove section of Stamford." http://en.wikipedia.org/wiki/Cove_section_of_Stamford.

"Cummings Park." http://en.wikipedia.org/wiki/Cummings_Park.

D'Entremont, Jeremy. *The Lighthouses of Connecticut.* Beverly, MA: Commonwealth Edition, 2005.

Fay, Francis X. "Raymonds Find Pair of Reasons to Celebrate the Past 50 Years." *Norwalk Hour*, December 1, 1984.

Gillespie, Edward T.W. *Picturesque Stamford.* Stamford, CT: Gillespie Brothers, 1892.

Huntington, E.B. *History of Stamford.* Corrected reprint of the 1868 edition. Harrison, NY: Harbor Hill Books, 1979.

Jewell, Karen. "Breakwater Irregulars Prepare Their Sails." *Norwalk Hour*, 2010.

Lobozza, Carl. *Stamford, Connecticut: Journey Through Time.* Stamford, CT: Stamford Historical Society, Inc., 1971.

"Luders 16 History." L16.org. http://www.l16.org/History.

Majdalany, Jeanne. *The History of the Cove in Stamford, Connecticut.* Stamford, CT: Stamford Historical Society, Inc., 1979.

Profile: Bill Luders. Sea Sprite Association. www.seasprites.com/profile_luders.asp.

"Sea Sprite 34." en.wikipedia.org/wiki/Sea_Sprite_34.

Sherwood, Herbert F. *The Story of Stamford.* New York: States History Company, 1930.

Snyder, Frank V. "Galerider Handles a Gale." *Yachting* magazine (September 1986).

Soundings. www.soundingsonline.com.

Stamford Advocate tercentenary edition, 1941.

"Stamford, Connecticut." http://en.wikipedia.org/wiki/Stamford,_Connecticut.

Stamford Harbor Lighthouse History. http://www.lighthouse.cc/stamford/history.html.

Stamford Historical Society, Stamford, Connecticut. www.stamfordhistory.org.

Stamford 350 Years, 1641–1991. Jointly organized and published by the *Stamford Advocate* and the Ferguson Library, Hong Kong, 1991.

Stamford Yacht Club. *One Hundred Years on Sound and Shore of Stamford Yacht Club 1890–1990.* Stamford, CT: Josten's Printing and Publishing, 1994.

Wallace, William N. "A Shipyard Legend Named Luders." *New York Times*, July 9, 1995.

World Port Source. Stamford Harbor. www.worldportsource.com/ports/USA_CT_Stamford_Harbor_3627.php.

About the Author

Karen Jewell writes a weekly column for the *Norwalk Hour* newspaper titled "Water Views," which is currently in its tenth year of publication. The theme centers on anything and everything that has to do with life along the waterfront. Her past work experience includes positions as dock master, yacht charter broker, yacht sales broker, sail loft staff and owner of a busy yacht maintenance service. Growing up along the coastline of Connecticut and having the opportunity to enjoy summer vacations along the shoreline of Maine her entire life, Jewell developed a passion for the water, boating and just about everything to do with life along the water at a very young age. Her affection for the sea has only grown stronger over the years, and learning about the unique history of the waterfront has been one of her favorite pastimes. This is Jewell's second book published with The History Press, having released *A History of the Rowayton Waterfront: Roton Point, Bell Island and the Norwalk Shoreline* in August 2010.

Visit us at
www.historypress.net